BIRDS AND FLOWERS
IN COLORED PENCIL

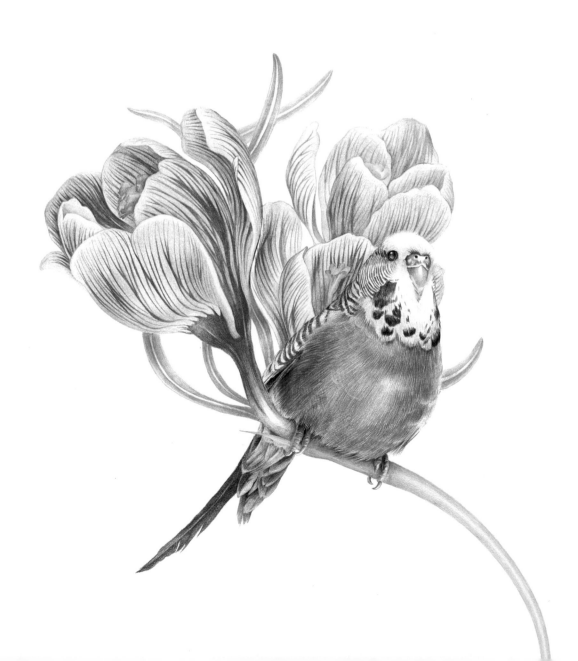

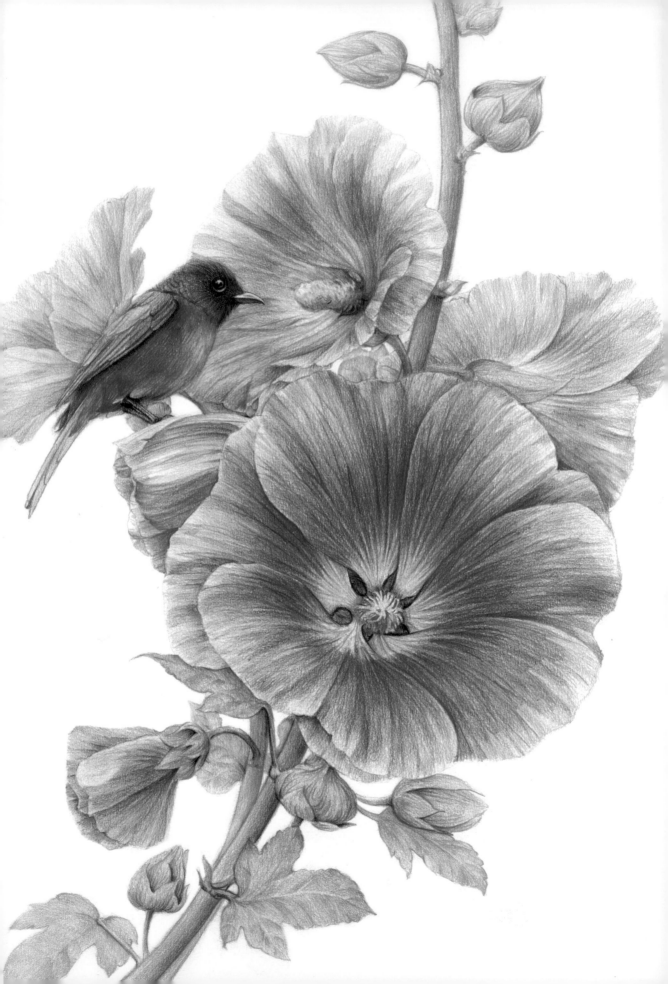

BIRDS AND FLOWERS IN COLORED PENCIL

Step-by-Step Tutorials and Techniques

By Fei Le Niao

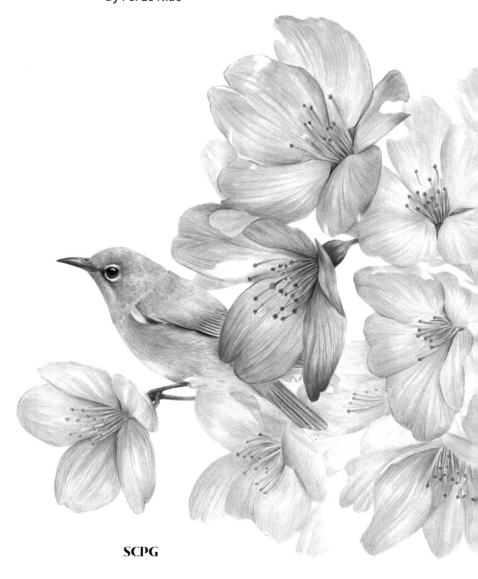

SCPG

On page 1
Fig. 1 *Saffron and Budgerigar*
Saffron is not only beautiful, but can also be made into traditional Chinese medicine that promotes blood circulation and removes blood stasis. With its reddish-purple hue, saffron adds warmth and color to the chilly, monotonous winter. A lovely, playful budgerigar is nestled among the flowers, creating a triangular composition to the whole painting, making it compact and balanced.

On page 2
Fig. 2 *Hollyhock and Minivet*
Originally from Sichuan, China, hollyhock is also known as the Dragon Boat Festival Flower because it blooms around the time of the festival. The red and blue minivet stands among the vibrant red hollyhocks, creating a captivating picture.

On page 3
Fig. 3 *Cherry Blossoms and Warbling White-Eye*
More than 2,000 years ago, cherry blossoms were already being cultivated within Chinese imperial gardens. In this painting, the combination of the pink cherry blossoms and the yellow-green white-eye bird highlights the charm of spring.

Text and Photographs: Fei Le Niao

Translation: Shelly Bryant

Cover Design: Shi Hanling

Interior Design: Hu Bin, Li Jing (Yuan Yinchang Design Studio)

Assistant Editor: Qiu Yan

Editor: Cao Yue

ISBN: 978-1-63288-012-3

Address any comments about *Birds and Flowers in Colored Pencil* to:

SCPG
401 Broadway, Ste. 1000
New York, NY 10013
USA

or

Shanghai Press and Publishing Development Co., Ltd.
Floor 5, No. 390 Fuzhou Road, Shanghai, China (200001)
Email: sppd@sppdbook.com

Printed in China by Shanghai Donnelley Printing Co., Ltd.

1 3 5 7 9 10 8 6 4 2

Fig. 4 *Painted Tongue Flowers*
Fiery red painted tongue bloom in a row on the branches, their flower shape resembling trumpets, as if proclaiming the good news of the opening of new life all around.

Contents

Fig. 5 *Parrots*
In Chinese traditional culture, parrots symbolize wisdom, kindness, and longevity. The curved flower branch forms a natural hammock, with two parrots nestling together, quietly resting on the branch.

Fig. 6 *Tulips and Flamingo*
The flamingo is surrounded
by pink tulips, its red feathers
glistening in the sunlight, as fiery
and intense as flames, symbolizing
carefree freedom. There is a
dreamlike beauty to the scene.

Preface

Bird-and-flower painting, one of the three major traditional genres in Chinese painting, depicts flowers, birds, insects, and animals. In primitive society, the ancestors of the Chinese nation used their artistic talents in the form of patterns on daily necessities. From the pottery fragments, bone carvings, and ivory carvings unearthed from Chinese Neolithic sites dating from approximately 7,000 years ago, we can already see beautifully decorated and meticulously crafted bird-and-flower patterns. After a long period of development, during the Sui and Tang dynasties (581–907), bird-and-flower painting gradually emerged from its role as a mere background and evolved into an independent genre of painting. Its form and content became increasingly diverse and rich, making it a popular choice for both the imperial court and the general public.

Colored pencils, as a commonly used artistic tool, offer a rich palette of colors, convenient portability, and simple usage. They can express a sense of lightness and transparency, creating various artistic effects that other tools and materials cannot achieve. When you want to capture the beauty of chance encounters or lovely things through drawing, the colored pencil is an excellent choice.

This book blends the traditional Chinese painting theme of birds and flowers with modern colored pencil techniques, condensing auspicious flora and fauna into vivid artworks. The flower shapes are exaggerated and lively, while the birds are depicted with a cute, playful demeanor. The emphasis is not on capturing the exact light and shadow, but rather on presenting the details. This book provides step-by-step tutorials to guide readers in creating their own beautiful illustrations. For the focal and challenging aspects within the paintings, it provides separate explanations in "Tip" section, which enable readers to acquire a wealth of practical knowledge on drawing.

By following this book, you can use beautiful, vibrant colors, along with lively, natural lines, to create bird-and-flower illustrations depicting different seasons and allow beautiful drawings to adorn your bedside, study, or dining table.

Fig. 7 *Japanese Anemone and Red-Billed Leiothrix*

The red-billed leiothrix always appears in pairs. It is a deeply affectionate species, symbolizing faithful love. In the painting, the red-billed leiothrix is perching on a cluster of beautiful Japanese anemone, gazing into the distance, as if waiting for his beloved to return.

How to Use This Book

This book follows the color perception of the changing seasons to create a harmonious color scheme for the illustrations. In terms of composition, it emphasizes the mutual harmony between birds and flowers by exaggerating their proportions. Additionally, this book provides a comprehensive analysis of the overall piece through complete illustrations, line drawings, composition explanations, and coloring techniques, highlighting the focal points and challenges within the image. The works in the book are created using Faber-Castell colored pencils, a set of 48 oil-based colors. If these specific-colored pencils are not available, you can use other oil-based colored pencils that have similar colors.

301 white	304 light yellow	307 lemon yellow
309 medium yellow	314 yellowish orange	316 reddish orange
318 scarlet red	319 pink	321 bright red
325 rose red	326 dark red	327 eosin
329 peach red	330 salmon	333 red purple
334 purple red	335 pale purple	337 purple
339 pink purple	341 dark purple	343 ultramarine blue
344 Prussian blue	345 lake blue	347 sky blue
348 silver	349 cobalt blue	351 dark blue
352 gold	353 navy blue	354 light blue
357 blue green	359 emerald green	361 phthalo green
362 light green	363 dark green	366 grass green
370 yellowish green	372 olive green	376 brown
378 ocher	380 dark brown	383 earth yellow
387 yellowish brown	392 burnt sienna	395 light gray
396 gray	397 dark gray	399 black

Fig. 8 Color chart of Faber-Castell oil-based 48-color colored pencil. The color blocks in the chart show the variation of depth based on the pressure at your pencil tip.

9

1. Line Drawing

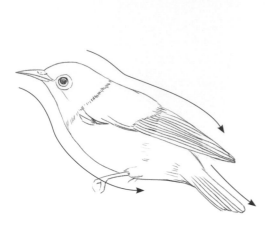

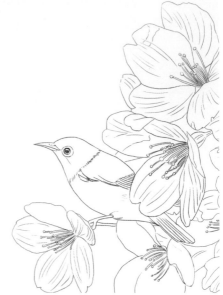

Most bird body shapes are streamlined (spindle or shuttle shaped), so when drawing, pay attention to capturing this characteristic outline of the bird and use elongated, flowing lines to depict it (as shown by the arrows).

After presenting the complete illustration, a complete line drawing will be provided, along with key points to note when depicting that line drawing.

2. Composition

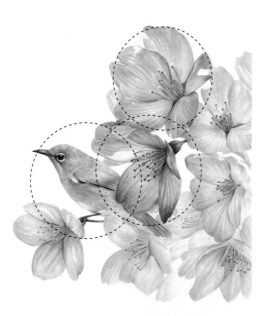

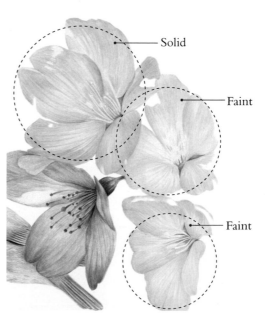

Before coloring each piece, a list of all the required colors is provided. Additionally, the key points of the illustration, composition analysis, and color combinations are accompanied by explanatory texts.

During the coloring process, there will also be graphic and textual analysis focusing on the treatment of solidity and emptiness (faint or faded color) in the composition.

3. Step-by-Step Explanation of the Drawing Process

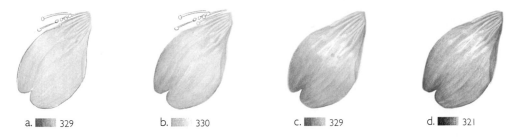

a. ■■■ 329 b. ▨▨ 330 c. ■■ 329 d. ■■■ 321

In the coloring steps, a detailed description of drawing techniques and items to consider during the drawing process are provided throughout text, aiming to help readers better understand and apply them.

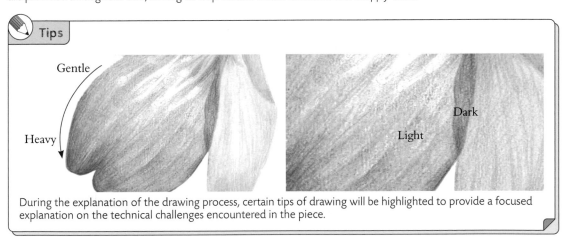

During the explanation of the drawing process, certain tips of drawing will be highlighted to provide a focused explanation on the technical challenges encountered in the piece.

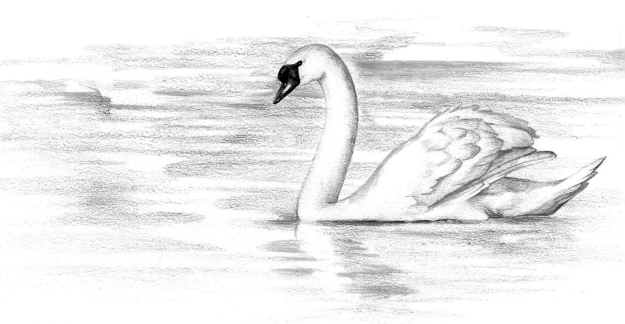

Fig. 9 *Swan*
The complete work is depicted in *Swan and Narcissus* on page 82.

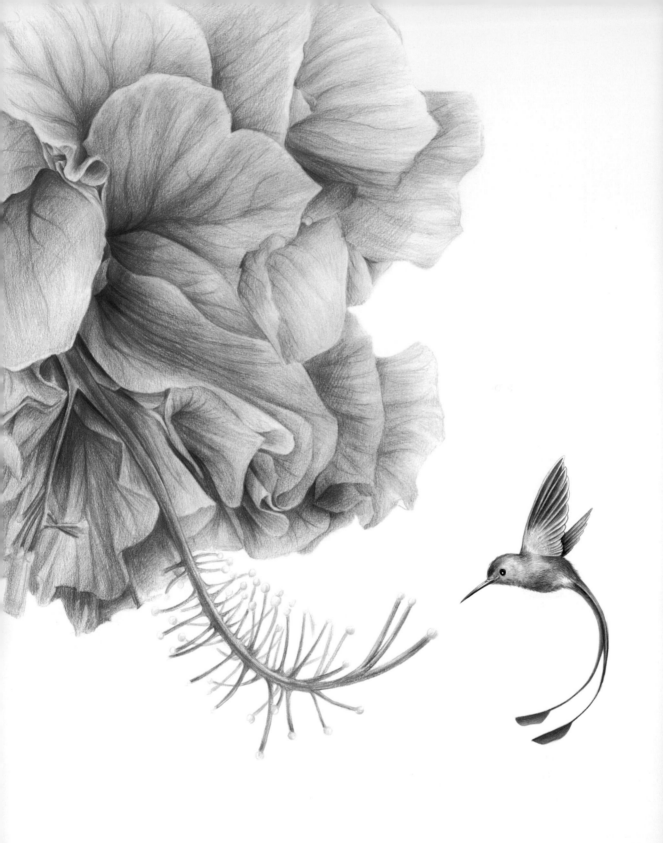

Hummingbird and Hibiscus

The hibiscus is extremely bright and festive in color. Its petals are like silk, shining brilliantly. In ancient China, women often wore it in their hair. Its core is slender, resembling the delicate heart beneath its passionate appearance, making the hibiscus a symbol for the beauty of thoughtfulness. It is not only a popular ornamental plant but also frequently mentioned in ancient Chinese poetry and medicinal literature. The petite, elegant hummingbird has a particular fondness for feeding on nectar, and the large, vibrant hibiscus is one of its delicacies.

In this piece, the hibiscus appears graceful and radiant, while the hummingbird is small and agile, hovering in mid-air. It rapidly flaps its wings, eagerly poised to plunge its beak into the flower and sip the nectar.

Line Drawing

The difficulty of this line drawing lies in capturing the intricate and varied vein patterns on the petals. It is advisable to first sketch the overall structure of the flower and then gradually refine the vein patterns on each petal. When drawing the intricate stamen, it is important to pay attention to the perspective and the relationship between the foreground and background elements. The overall shape of the hummingbird is spindle-shaped, and you can represent the feathers on its wings with smooth, flowing lines.

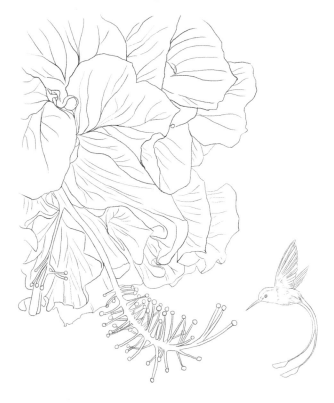

Colors Used

330 salmon		329 peach red		318 scarlet red	
319 pink		321 bright red		327 eosin	
339 pink purple		335 pale purple		337 purple	
341 dark purple		349 cobalt blue		344 Prussian blue	
307 lemon yellow		309 medium yellow		314 yellowish orange	
383 earth yellow		378 ocher		366 grass green	

Composition

This piece utilizes an exaggerated approach by portraying the flower as large and the bird as small, emphasizing the brilliance of the flower and contrasting it with the delicacy of the bird. Additionally, the composition employs an S-shaped diagonal line to create a sense of rhythm and enhance the visual impact of the piece. The dashed lines enclose the focal points of the composition.

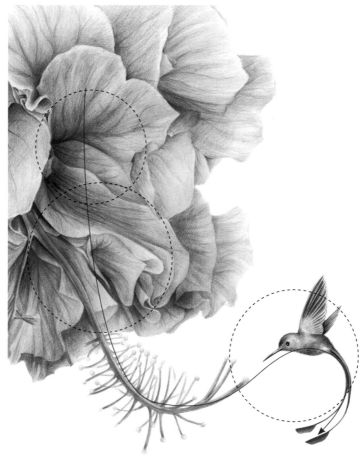

Steps

1

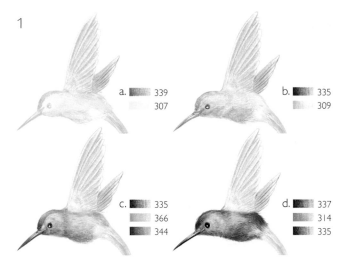

a. ▓ 339
▓ 307

b. ▓ 335
▓ 309

c. ▓ 335
▓ 366
▓ 344

d. ▓ 337
▓ 314
▓ 335

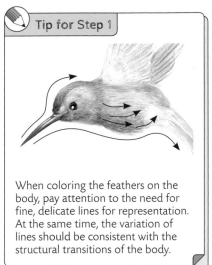

Tip for Step 1

When coloring the feathers on the body, pay attention to the need for fine, delicate lines for representation. At the same time, the variation of lines should be consistent with the structural transitions of the body.

When applying the base colors of lemon yellow and pink purple, which are complementary colors, it is important to be mindful of the areas where the colors are applied. Be cautious to avoid blending the complementary colors (in this case, lemon yellow and pink purple) together, as it may result in a darker or grayer appearance. When adding shade to the hummingbird's body, it is important to use lighter lines and maintain a sharper pencil point. Apply the pencil lines in the direction of the feathers, layering them gently. When deepening the details in the dark areas, you can consider the hummingbird as a sphere, with the color gradually lightening from the edges to the center.

2

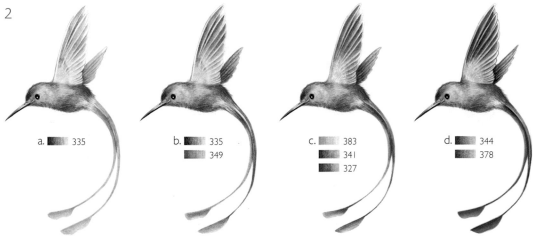

a. ▓ 335

b. ▓ 335
▓ 349

c. ▓ 383
▓ 341
▓ 327

d. ▓ 344
▓ 378

Depict the wings and tail feathers of the hummingbird. Start by lightly layering the color using a pale purple hue on the wings and tail. Then, use a combination of pale purple and cobalt blue with fine lines to deepen the shadows. Pay attention to the use of white space between the feathers of the wings. With sharp Prussian blue and ocher pencils, apply more pressure while using the tip to emphasize the detailed parts of the dark crevices.

Tips for Step 2

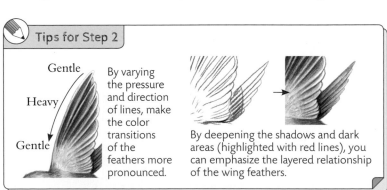

By varying the pressure and direction of lines, make the color transitions of the feathers more pronounced.

By deepening the shadows and dark areas (highlighted with red lines), you can emphasize the layered relationship of the wing feathers.

3

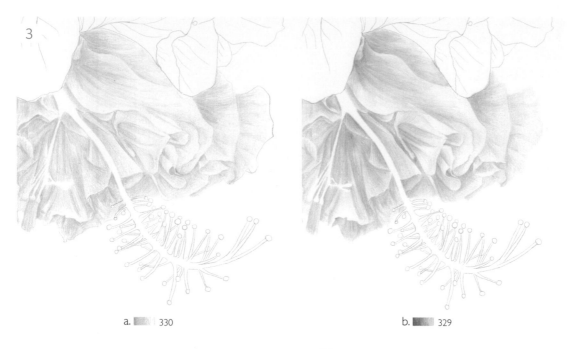

a. ▮▮▮ 330

b. ▮▮▮ 329

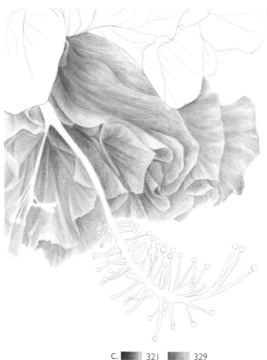

c. ▮▮▮ 321 ▮▮▮ 329

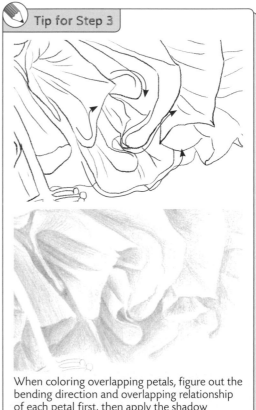

Tip for Step 3

Depict the petals of the hibiscus near the stamen. Start by gently applying a base color with very light pressure, and then deepen the color of the petals. Carefully create a gentle color gradient toward the inner edges of the petals. Then, use a sharp bright red pencil to layer additional color on the shadows of the petals. Pay attention to following the direction of the petal's curves while drawing, so that the colors appear cohesive and neat.

When coloring overlapping petals, figure out the bending direction and overlapping relationship of each petal first, then apply the shadow areas accordingly. To create a more defined outline of the petals, gently create a gradual color transition along the edges of the petals, extending outward. This will enhance the clarity of the petal's contours.

4

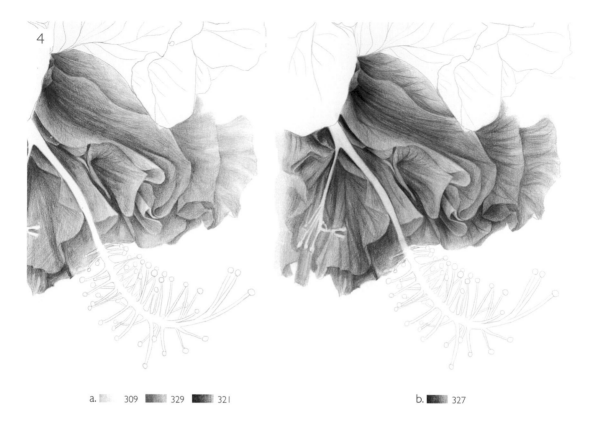

a. ▨ 309 ▨ 329 ▨ 321 b. ▨ 327

Gently apply the dark areas of the petals with a light touch of bright red, continuing to deepen the color. When deepening the shadows, control the pressure of your lines to achieve a natural variation in color intensity. As the color of the petals transitions from the base to the tip, it gradually becomes lighter. Hold a sharp eosin pencil upright and use firm lines to depict the dark details between the petals. Then, using smooth, elongated lines, follow the curling direction of the petals to draw the texture on the surface of the petals.

Tips for Step 4

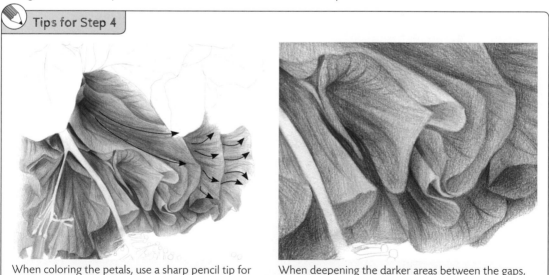

When coloring the petals, use a sharp pencil tip for depicting. Ensure that the direction of your lines aligns with the growth direction of the petals.

When deepening the darker areas between the gaps, avoid darkening them too much all at once. Make sure to create a color gradient along the edges of the petals, extending outward to give a more breathable, natural appearance to the color of the dark gaps and avoid a rigid, flat look.

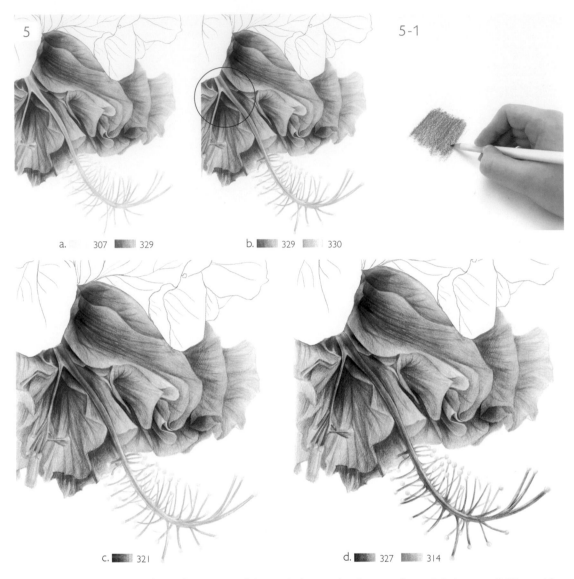

5

5-1

a. ░░ 307 ▓▓ 329

b. ▓▓ 329 ░░ 330

c. ▓▓ 321

d. ▓▓ 327 ▓▓ 314

Control your lines as you apply gentle pressure while evenly drawing (as shown in figure 5-1, draw parallel lines with the pencil in a uniform manner, applying only one layer of color without overlapping) with peach red and lemon yellow to apply a base color for the stamen, using lemon yellow to depict the anthers. Next, layer with salmon and peach red. Darken the area of the stamen closer to the center of the flower (as indicated by the red circle) to differentiate the front and back of the stamen. Use a sharp bright red pencil to draw the outline edges of the small stamen and use eosin to enhance the contrast between light and dark in the shadowed areas, emphasizing the three-dimensional effect of the stamen.

Tip for Step 5

Before coloring the stamen, it can be helpful to simplify the complex structure of the stamen and understand its growth characteristics and overall structure.

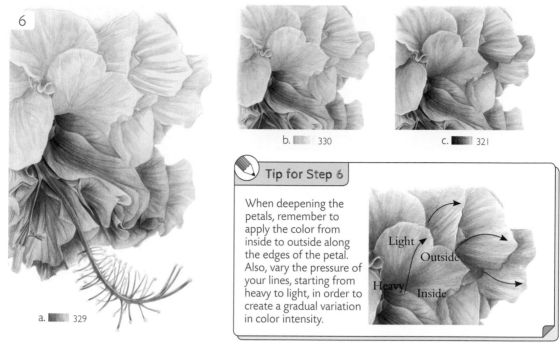

6

a. � 329

b. ▪▪▪ 330

c. ▪▪▪ 321

Tip for Step 6

When deepening the petals, remember to apply the color from inside to outside along the edges of the petal. Also, vary the pressure of your lines, starting from heavy to light, in order to create a gradual variation in color intensity.

Light

Outside

Heavy

Inside

The petals that are flipped upward should be slightly lighter in color compared to the stamen. Follow the same method used for drawing the petals around the stamen to refine the petals that are flipped upward. Be careful to create a natural look for the edges that are flipped and utilize white space to enhance the glossy effect of the petals. You can selectively deepen the overlapping areas of the petals with bright red to emphasize the layered relationship between the petals.

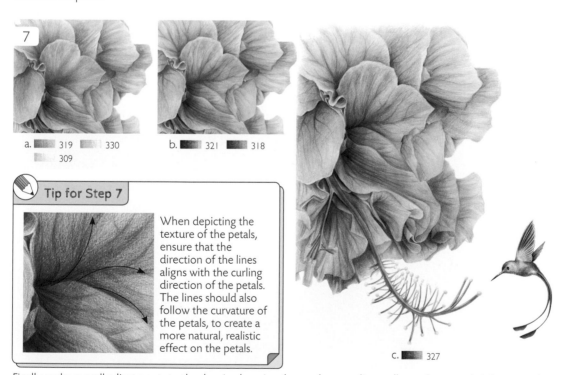

7

a. ▪▪▪ 319 ▪▪▪ 330
 ▪▪▪ 309

b. ▪▪▪ 321 ▪▪▪ 318

Tip for Step 7

When depicting the texture of the petals, ensure that the direction of the lines aligns with the curling direction of the petals. The lines should also follow the curvature of the petals, to create a more natural, realistic effect on the petals.

c. ▪▪▪ 327

Finally, make overall adjustments to the drawing by using three colors: medium yellow, salmon, and pink, to enrich the color variations in the reflective parts of the petals. Use scarlet red and bright red to deepen the veins on the petals, enhancing the texture of the hibiscus. Finally, use eosin to emphasize the shadows between the petals, adding more depth and enhancing the three-dimensional effect.

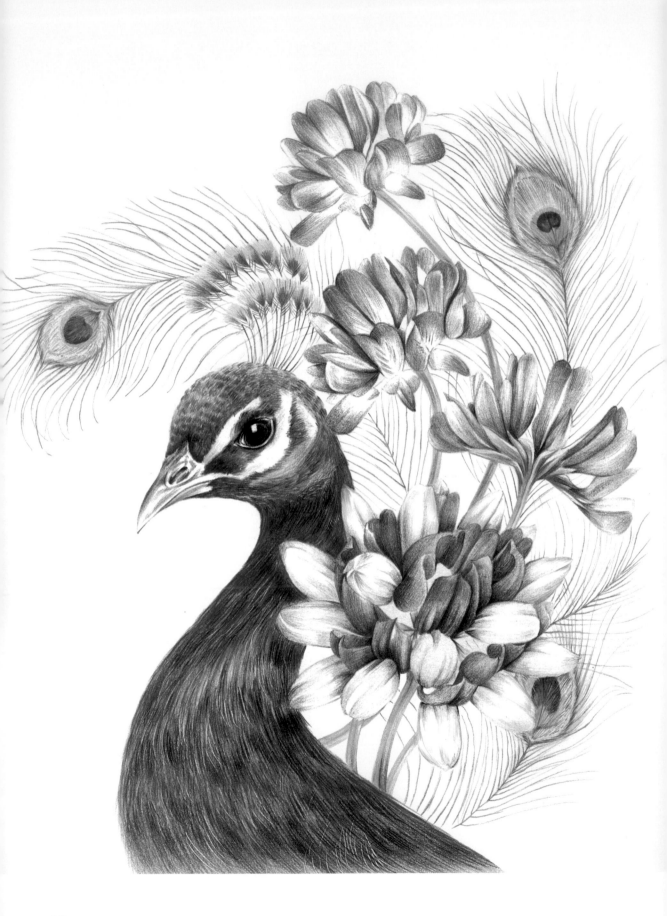

Peacock and Chinese Milkvetch

Early spring is the season when Chinese milkvetch (Astragalus sinicus) is in full bloom. Its purplish red flowers grow among the bright green leaves. The oval-shaped leaves are arranged symmetrically along the slender flower stems, forming a feathery pattern that resembles layers of overlapping wings swaying gracefully in the gentle spring breeze. The blooming flowers are like auspicious purple clouds, covering the lush green grass. Peacocks stroll among them, dragging their long tails. Since ancient times, the Chinese have regarded peacocks as noble, auspicious birds. Having peacock decorations at home is symbol of good fortune meant to bring luck.

In this piece, the voluminous purple flowers create an elegant, enchanting atmosphere, captivating the viewer. A peacock in the midst of displaying its vibrant plumage sits in this scene, exhibiting its graceful poses.

Line Drawing

The feathers on the peacock's head can be depicted using short lines. When drawing, it is important to ensure that the lines are crisp. The feathers on the body and the subtle feathers can be portrayed using flowing curves. The corolla of the Chinese milkvetch can be depicted using smooth, curved lines.

Colors Used

307 lemon yellow	383 earth yellow	387 yellowish brown
378 ocher	376 brown	330 salmon
319 pink	329 peach red	333 red purple
335 pale purple	339 pink purple	341 dark purple
337 purple	343 ultramarine blue	344 Prussian blue
347 sky blue	349 cobalt blue	351 dark blue
345 lake blue	366 grass green	361 phthalo green
359 emerald green	357 blue green	399 black

Composition

Treat the color of the Chinese milkvetch with a slight lean toward purple, blending it more harmoniously with the colors of the peacock. Give the overall image a cooler bluish-purple tone, portraying the lingering chill of late winter and early spring. Exaggerate the size ratio between the Chinese milkvetch and the peacock, allowing them to intersect with each other. Add some tail feathers in the background as embellishments to make the composition more dynamic. The highlighted focus of the composition should be on the peacock's head and the two prominent Chinese milkvetches in the foreground.

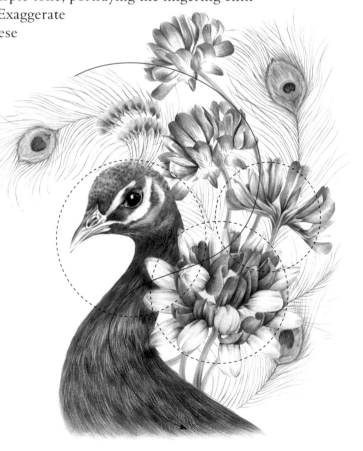

Steps

1

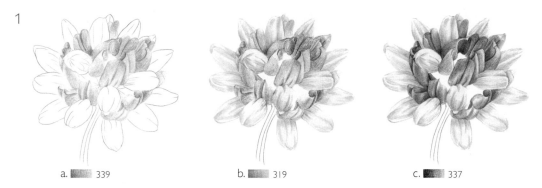

a. ▮▮▮ 339 b. ▮▮▮ 319 c. ▮▮▮ 337

First, color the closest Chinese milkvetch in the image. Use a pink purple pencil tip to gently draw along the direction of petal growth, creating a light base color for the shaded areas. Next, use pink to create another layer of color in the shaded areas of the outer and inner petals. Finally, with a sharp purple pencil, deepen the color of the inner petals.

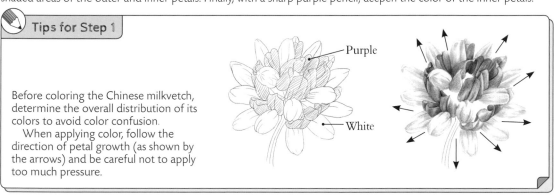

Tips for Step 1

Before coloring the Chinese milkvetch, determine the overall distribution of its colors to avoid color confusion.

When applying color, follow the direction of petal growth (as shown by the arrows) and be careful not to apply too much pressure.

Purple

White

2

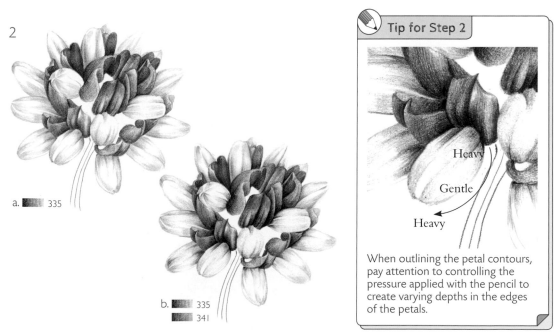

a. ▮▮▮ 335

b. ▮▮▮ 335
▮▮▮ 341

Tip for Step 2

Heavy

Gentle

Heavy

When outlining the petal contours, pay attention to controlling the pressure applied with the pencil to create varying depths in the edges of the petals.

In the creases of the shaded areas and the gaps between contours, use the pencil tip to emphasize and deepen the details. Apply a gradient of color from the base to the outer edges using gentle lines, enhancing the richness of the entire corolla.

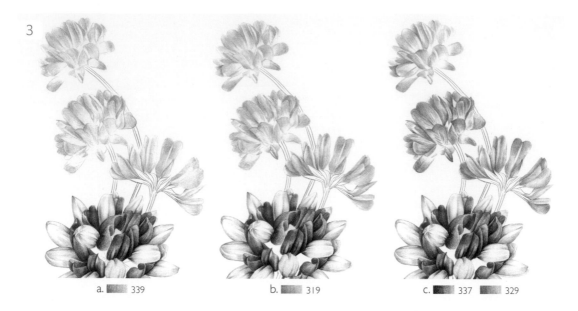

3

a. ▮▮ 339 b. ▮▮ 319 c. ▮▮ 337 ▮▮ 329

Apply a light base color using pink purple and pink and layer the colors on the three flowers in the background. Pay attention to the umbrella-like shape of the corollas and ensure that the lines follow the direction of corolla growth. Then, with a layering technique, overlay the colors on the petals to make them more vibrant and varied.

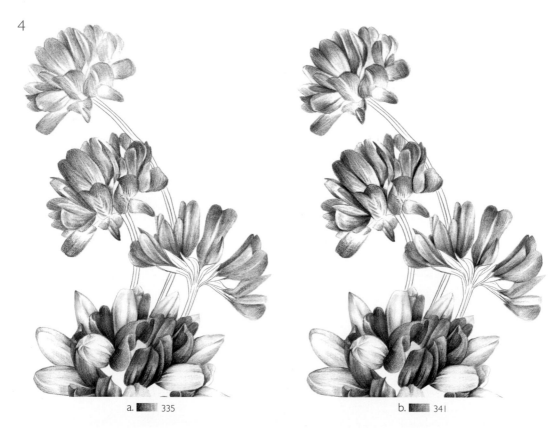

4

a. ▮▮ 335 b. ▮▮ 341

With a sharp pale purple pencil, follow the curved direction of the petal contours to refine the edge outlines of the entire corolla. Pay attention to the variation in line weight while sketching. With dark purple, deepen all the petals, and then again use dark purple to create shading at the overlapping parts of the petals.

5

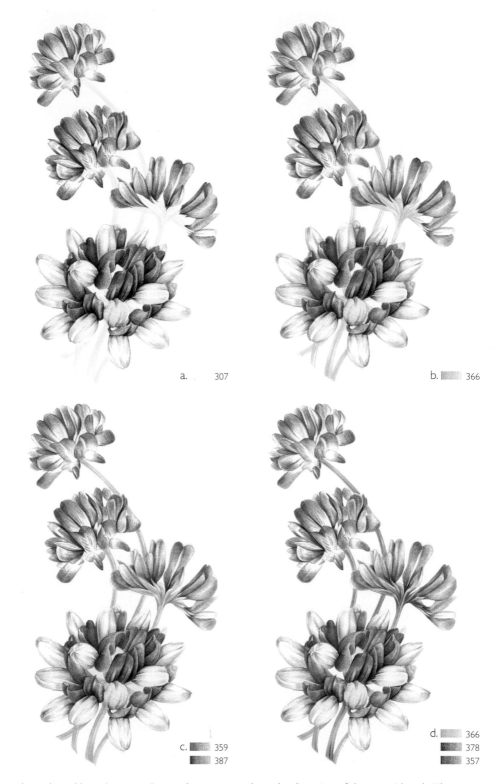

a. 307

b. ▨ 366

c. ▨▨ 359
 ▨▨ 387

d. ▨ 366
 ▨ 378
 ▨ 357

First, gently apply and layer lemon yellow and grass green along the direction of the stems' bends. Then, use emerald green and yellowish brown pencils to deepen the shaded areas of the stems and flower receptacles. Use blue green and ocher pencils to further deepen the shadows of the stems and flower receptacles. Then, lightly layer grass green over them.

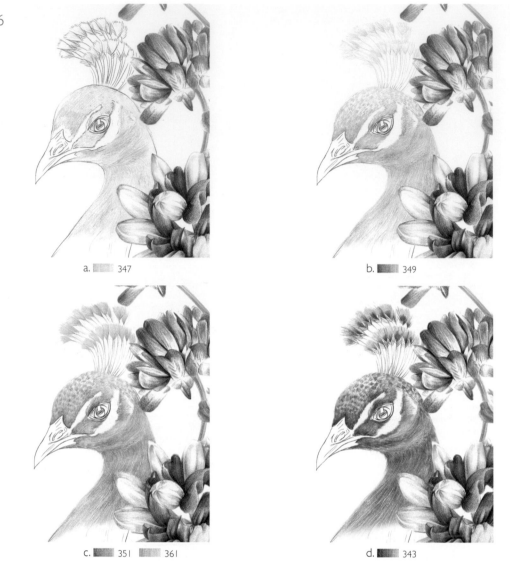

a. ▮▬ 347

b. ▮▬ 349

c. ▬▬ 351 ▬▬ 361

d. ▮▬ 343

First, gently apply and layer the base color and shadow color on the peacock's head and neck using very light, soft lines. Next, sharpen the pencil and with a series of fine, short lines, create the texture of the feathers along the direction of the head. Use an ultramarine blue pencil tip to depict the fine down feathers and crest with short, extremely fine lines.

Tips for Step 6

Light

Dark

When depicting the colors of the peacock's head, pay attention to the overall tonal variation of the head and use variations in color depths to portray it.

First, clarify the general shape of the crest, and then proceed with coloring and adding details. This approach helps avoid mistakes and ensures accuracy.

7

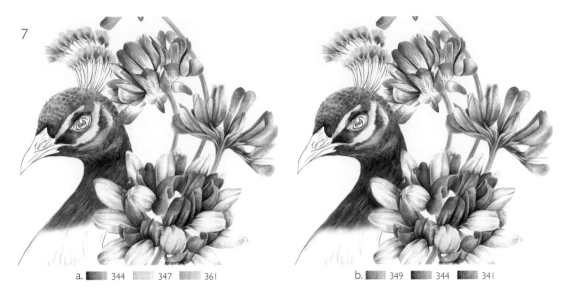

a. ■ 344 ▦ 347 ▦ 361 b. ■ 349 ▦ 344 ▦ 341

With a sharp Prussian blue pencil, carefully and smoothly deepen the shadowed areas of the peacock's head, especially around the beak, eye, and the curved areas of the neck. Then, layer sky blue and phthalo green on the highlighted areas. Next, use cobalt blue, Prussian blue, and dark purple to further darken the area around the peacock's beak. Apply more pressure with the pencil to depict the details of the eye socket.

8

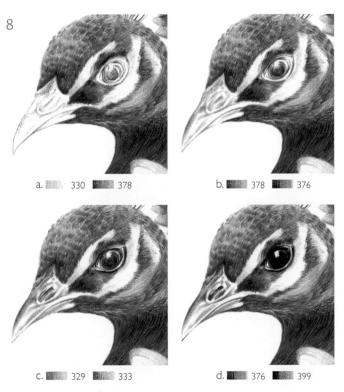

a. ▦ 330 ■ 378 b. ■ 378 ▦ 376

c. ■ 329 ▦ 333 d. ▦ 376 ▦ 399

Based on the structure of the beak and eye, apply a base color to each area. Then, increase the pressure with the pencil to deepen the shadowed areas. Be sure to leave the highlights on the eye. To add more variation to the colors on the beak and eye, you can use sharp peach red and red purple pencils to lightly layer the colors. Then, use brown and black to deepen the pupil by making circular lines, and darken the edges and crevices of the beak by following the shape of the pattern.

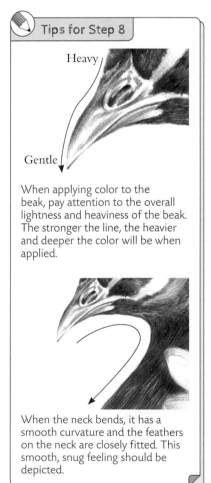

✎ Tips for Step 8

Heavy

Gentle

When applying color to the beak, pay attention to the overall lightness and heaviness of the beak. The stronger the line, the heavier and deeper the color will be when applied.

When the neck bends, it has a smooth curvature and the feathers on the neck are closely fitted. This smooth, snug feeling should be depicted.

9

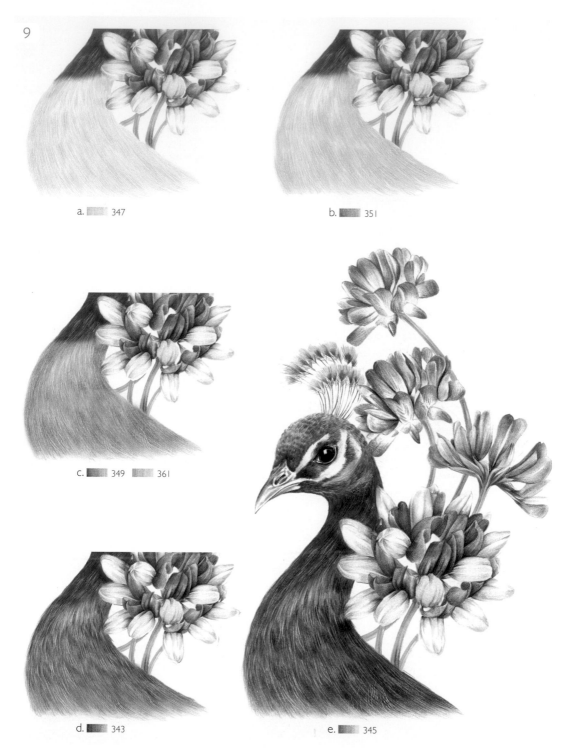

a. ▓▓ 347

b. ▓▓ 351

c. ▓▓ 349 ▓▓ 361

d. ▓▓ 343

e. ▓▓ 345

Using the tip of a mechanical pencil with no lead refill, crave out some fine feather lines on the chest and abdomen following the direction of feather growth. This will allow the grooves to automatically remain blank when coloring later. Gently blend and deepen the color on the chest following the direction of the feathers. Then, apply more pressure to the pencil to create delicate, clustered lines, emphasizing the texture of the feathers on the chest. At the junction of the neck and chest, use an ultramarine blue pencil to draw thin, elongated lines for a transitional effect. The lines should gradually transition from light to dark as you move from top to bottom. Finally, use short strokes to create color variations in the dark and light details of the feathers.

10

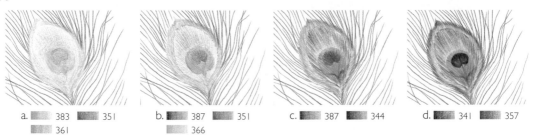

a. ▬ 383 ▬ 351
▬ 361

b. ▬ 387 ▬ 351
▬ 366

c. ▬ 387 ▬ 344

d. ▬ 341 ▬ 357

Apply a base color using earth yellow, dark blue, and phthalo green, according to the growth characteristics of the feather tips. Then, layer and deepen the colors using yellowish brown, dark blue, and grass green. Next, use yellowish brown along with Prussian blue, dark purple, and blue green pencil tips to depict the details and shadows of the feather tips.

11

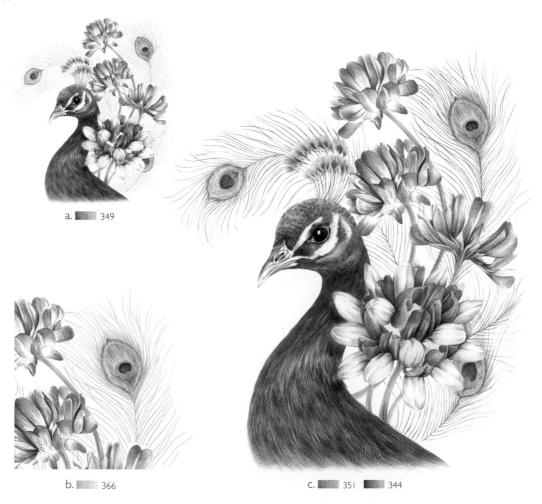

a. ▬ 349

b. ▬ 366

c. ▬ 351 ▬ 344

Use cobalt blue to draw long, fine, smooth lines to depict the slender tail covert. Then, use grass green to create a gradient layer around all the eye-shaped feather tips, starting from the inside and gradually transitioning toward the outer edges. Finally, use dark blue and Prussian blue pencils to carefully depict the feathers on the tail covert with intricate details.

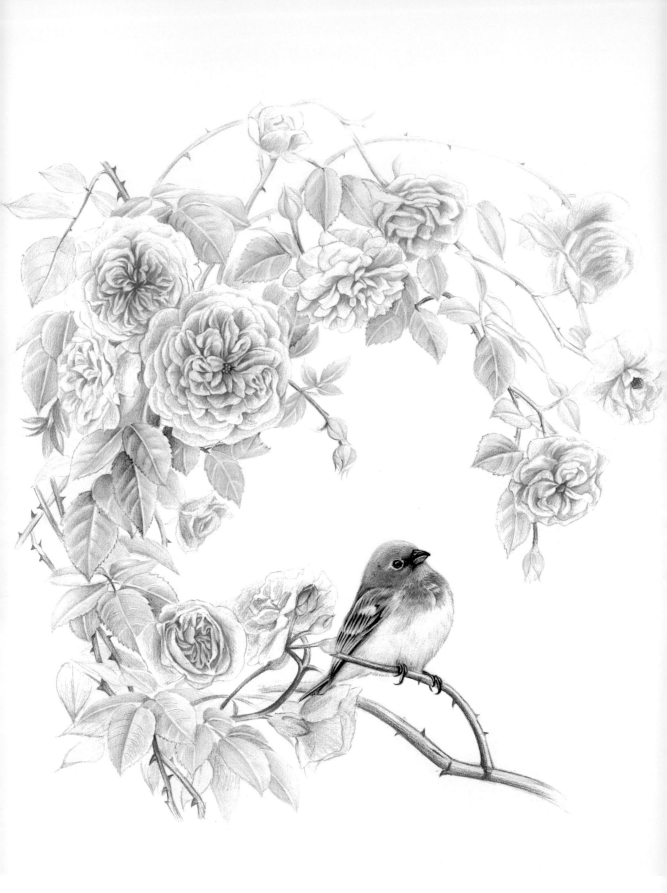

Robin and Yellow Rose

The yellow rose, native to China, usually blooms around the time of Grain Rain (one of the twenty-four Chinese solar terms, between April 19th and 21st). It has abundant blooms in various colors, which blossom on the branches and sway in the breeze. The twisting vines and the lightly adorned flowers create a poetic, picturesque scene. The yellow rose, with its warm color, symbolizes love and longing, while the more tender yellow rose represents eternal guardianship. The robin, which is loyal to a single partner throughout its life, is also a symbol of faithful love.

In this piece, a cluster of delicate, vibrant pale yellow roses is in full bloom. A small, adorable robin, drawn by the allure of the flowers, perches on a branch, seemingly whispering gently to the blossoms, its beauty on display.

Line Drawing

Create the line draft using a mechanical pencil. Since there are many flowers and leaves, start by determining the direction of the branches and leaves. Then, establish the positions of the flower and leaf clusters. Finally, patiently depict the details of the bird and flower branches. When drawing the leaves, make sure to depict their overlapping relationship in terms of foreground and background layers.

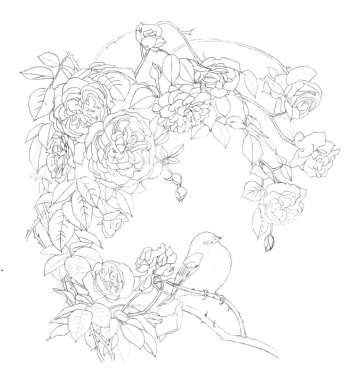

Colors Used

330 salmon	319 pink	316 reddish orange
321 bright red	314 yellowish orange	309 medium yellow
304 light yellow	378 ocher	387 yellowish brown
370 yellowish green	366 grass green	363 dark green
372 olive green	357 blue green	349 cobalt blue
353 navy blue	339 pink purple	399 black

Composition

Use the soft flower branches of the roses to create a C-shape, this composition will effectively showcase the alluring nature of the flowers. Place the bird at the bottom, slightly towards the middle of the C-shape, forming a smooth rhythm with the clustered flowers. The composition contains many objects and is quite complex, so it is important to focus on the key elements for depiction. First, draw the robin, and then focus on the several clusters of roses within the dashed outline.

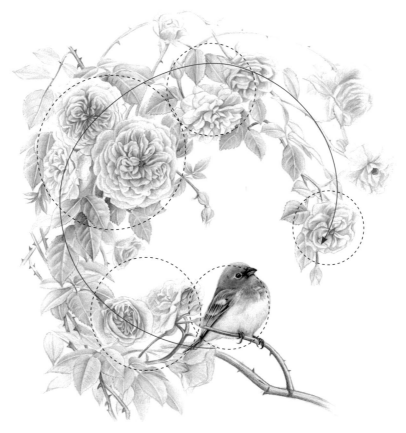

Steps

1

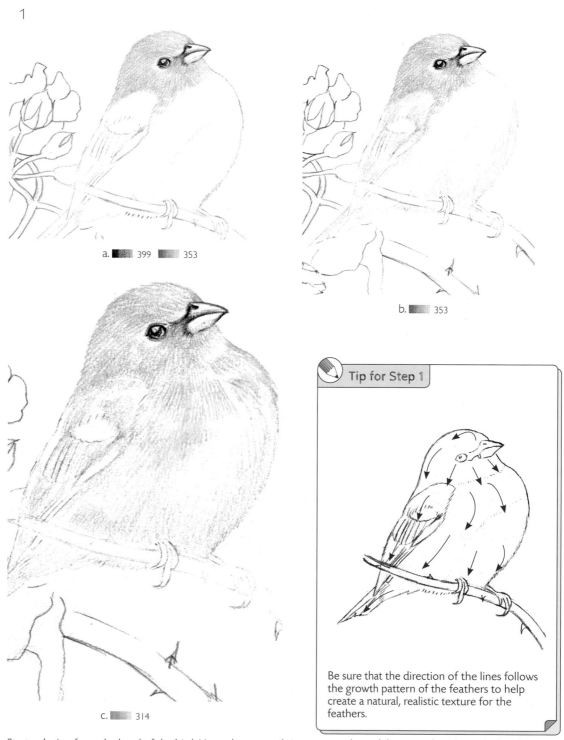

a. � 399 ▥ 353

b. ▥ 353

c. ▥ 314

Tip for Step 1

Be sure that the direction of the lines follows the growth pattern of the feathers to help create a natural, realistic texture for the feathers.

Start coloring from the head of the bird. Use a sharp pencil tip to create short, delicate strokes along the head to depict the short feathers. Leave the highlight of the eye blank. Gently apply navy blue to the wing and abdomen. Finally, use gradient coloring to lightly apply yellowish orange feathers to the front chest area and add some dots to the head and the wing.

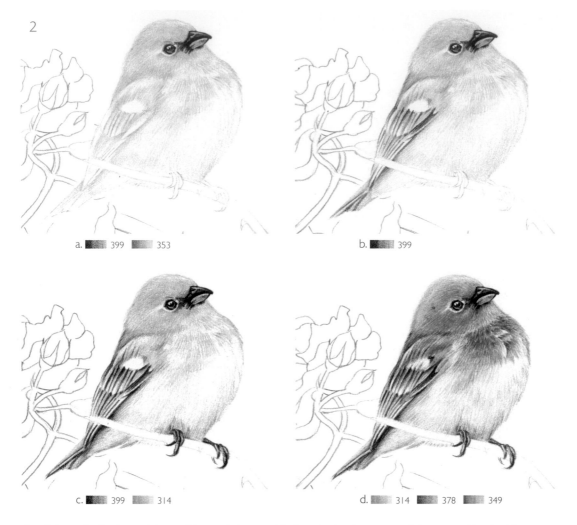

a. ▰▰ 399 ▰ 353

b. ▰ 399

c. ▰▰ 399 ▰ 314

d. ▰ 314 ▰▰ 378 ▰▰ 349

Gently layer the feathers with navy blue, and then use black to depict the texture of the eye and beak with more detail. Use long, linear lines to depict the black details on the long feathers of the wing. After applying the base color to the claws, with a sharp black pencil, outline the shape and shadow of the claws. Then, lightly emphasize the overlapping areas of the wing and body. Use short strokes with yellowish orange to depict the short fluff on the chest, and use ocher to accentuate the darker areas. Finally, use cobalt blue to deepen the blue parts of the feathers.

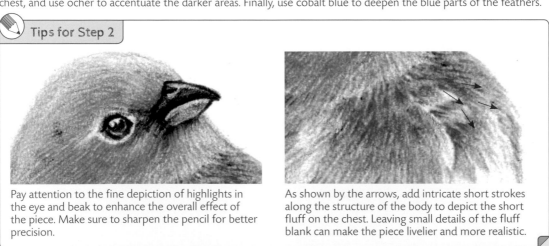

Tips for Step 2

Pay attention to the fine depiction of highlights in the eye and beak to enhance the overall effect of the piece. Make sure to sharpen the pencil for better precision.

As shown by the arrows, add intricate short strokes along the structure of the body to depict the short fluff on the chest. Leaving small details of the fluff blank can make the piece livelier and more realistic.

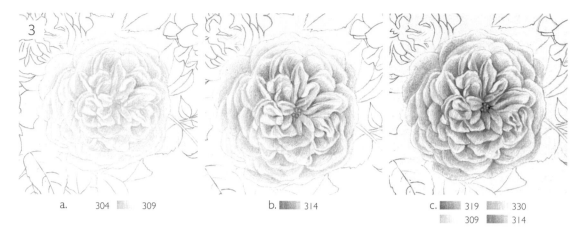

3

a. 304 309 b. 314 c. 319 330
 309 314

Apply light yellow as the base for the rose, while using a medium yellow to emphasize the overlapping areas of the petals. Then, use yellowish orange to enhance the depiction of the flower's stamen and dark areas. To enrich the color tones of the flower, you can layer salmon and pink on the petals. Additionally, you can repeat the use of medium yellow to deepen the color of the petals. Use yellowish orange to further define the dark areas, enhancing the three-dimensional effect of the flowers.

Tips for Step 3

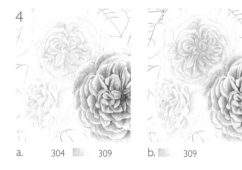

For the yellow tones of the roses, apply a heavier layer of yellow toward the center and gradually lighten the application of yellow toward the edges.

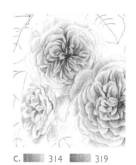

To depict the texture of the petals, whether coloring or shading the dark areas, it is important to leave the edges of the petals blank, as shown in the white areas in the image.

4

a. 304 309 b. 309 c. 314 319

Use the same method to depict the other flowers. Start by gently applying the base color for the flowers and emphasize the light and shadow relationship of the petals. Maintain a sharp pencil tip and enhance the sense of layering by following the direction of overlapping petals. Then, use yellowish orange to emphasize the dark areas of the flowers. Add a touch of pink at the edges of the petals.

Tip for Step 4

When depicting a cluster of roses, it is important to differentiate between the main and secondary elements to create a sense of depth and layering in the piece. In this group of flowers, the largest and foremost flower is the primary subject of depiction. The two flowers on the left side are secondary subjects, with the one on the top requiring more delicate detailing than the one on the bottom.

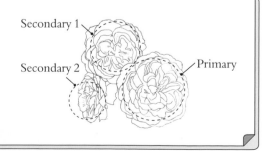

Secondary 1
Secondary 2
Primary

5

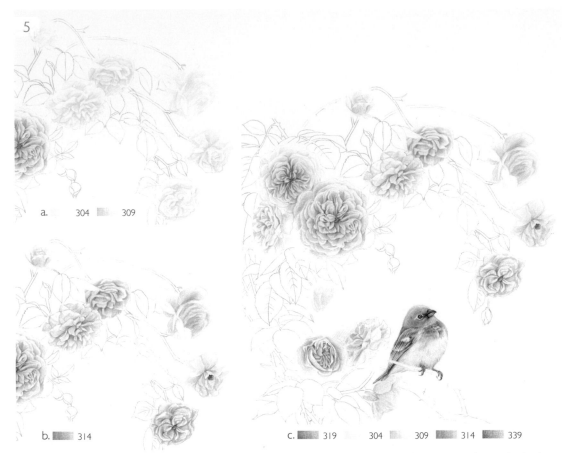

a.　　304　▮　309

b.　▮▮ 314

c.　▮▮ 319　　　304　▮　309　▮▮ 314　▮▮ 339

Referring to steps 3 to 4, draw all the flowers. Separate the area around the upper right corner and near the bird to draw the flowers. Start by applying light yellow and medium yellow to establish the base color and the light and shadow relationship of the flowers. Then, use yellowish orange to deepen the dark areas of the flowers. The difference is that you use pink to apply a color gradient to the edges of the flowers in the upper right corner and pink purple to apply a color gradient to the edges of the flowers near the bird.

6

▮▮ 366
▮ 309
▮▮ 316

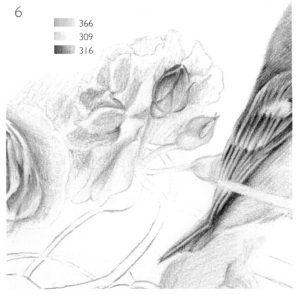

Use medium yellow to evenly color the petals in the center of the flower buds. Transition to reddish orange at the top of the petals. Then, use grass green to draw the sepals and receptacles, paying attention to capturing the light and shadow relationship of the receptacles.

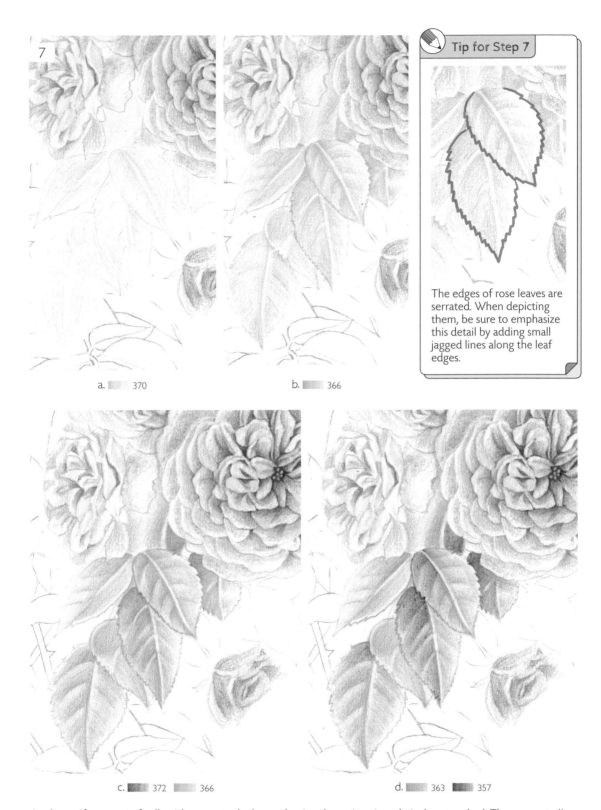

7

Tip for Step 7

The edges of rose leaves are serrated. When depicting them, be sure to emphasize this detail by adding small jagged lines along the leaf edges.

a. 370

b. 366

c. 372 366

d. 363 357

Apply a uniform coat of yellowish green to the leaves, leaving the main veins relatively untouched. Then, repeatedly layer grass green on the leaves, gently emphasizing the edges and shaded areas of the leaves with olive green. Then, use dark green to emphasize the shaded areas of the leaves, especially where the leaves overlap. Finally, with a sharp pencil, intensify the color in the darkest areas of the foliage.

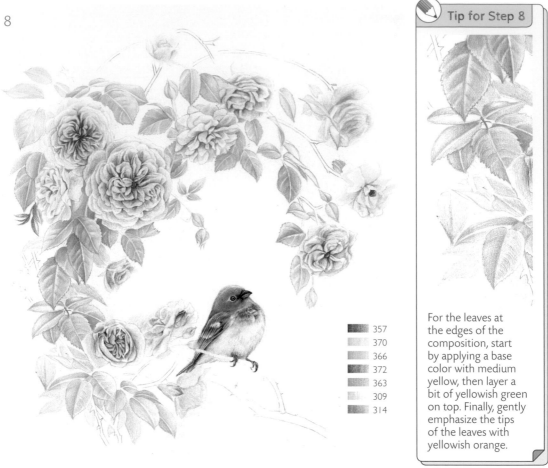

Tip for Step 8

357
370
366
372
363
309
314

For the leaves at the edges of the composition, start by applying a base color with medium yellow, then layer a bit of yellowish green on top. Finally, gently emphasize the tips of the leaves with yellowish orange.

Referring to step 7, use the same colors to depict most of the leaves. For the outermost leaves, you can add some medium yellow and yellowish orange to enhance the layering of the leaves and add depth.

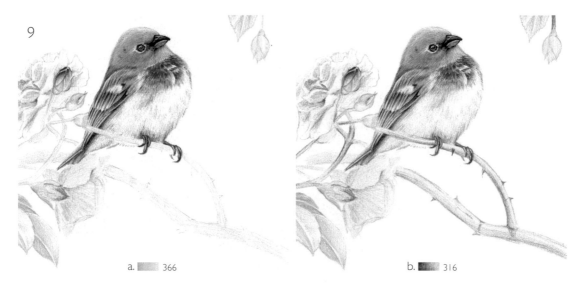

9

a. 366 b. 316

Apply an even layer of grass green as the base color for the rose branches. When drawing, follow the direction of the branches' growth. Next, lightly apply reddish orange to certain areas of the branches, mainly around the nodes and darker sections. Also, draw triangular thorns along the branches.

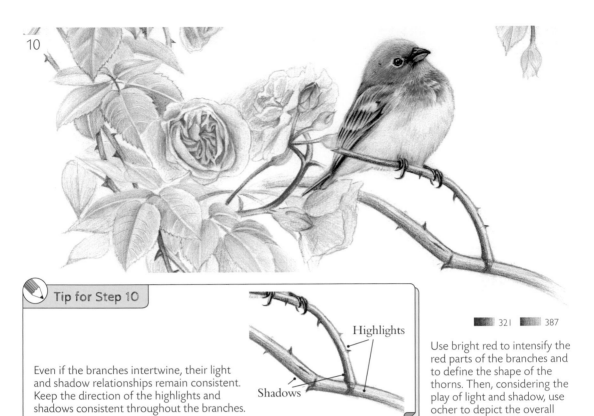

10

Tip for Step 10

Even if the branches intertwine, their light and shadow relationships remain consistent. Keep the direction of the highlights and shadows consistent throughout the branches.

Highlights

Shadows

■— 321 ■— 387

Use bright red to intensify the red parts of the branches and to define the shape of the thorns. Then, considering the play of light and shadow, use ocher to depict the overall dark areas of the branches.

Tips for Step 11

11

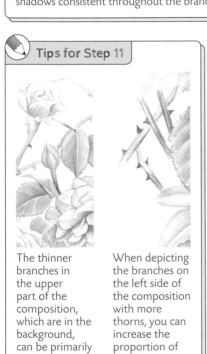

The thinner branches in the upper part of the composition, which are in the background, can be primarily depicted with grass green. Just lightly add some touches of red orange for the thorns.

When depicting the branches on the left side of the composition with more thorns, you can increase the proportion of reddish orange and bright red while coloring.

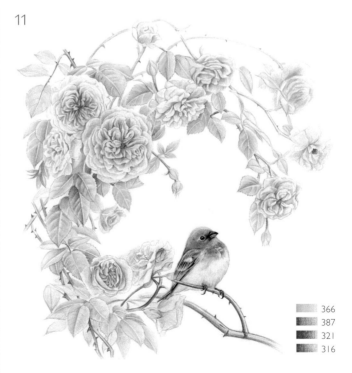

■— 366
■— 387
■— 321
■— 316

Finally, refer to steps 9 to 10 for the drawing technique and colors and depict the remaining branches in the picture.

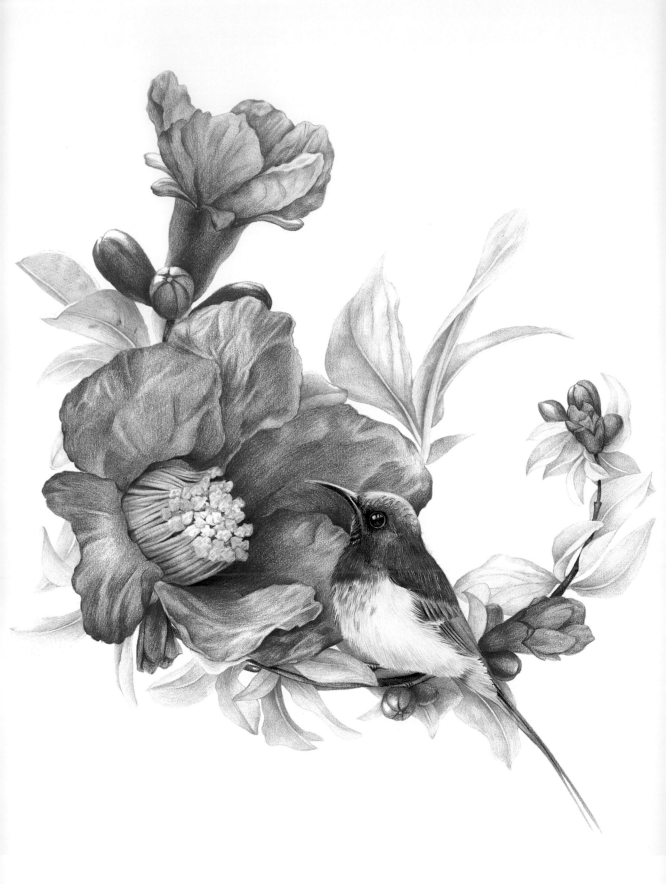

Sunbird and Pomegranate Flower

In early summer, pomegranate flowers are in full bloom, with vibrant, fiery colors. The flowers resemble bells hanging from the branches, swaying gently like red skirts in the breeze. The stamens form intricate golden webs, shimmering with a golden glow. The fiery red pomegranate flowers symbolize joy, prosperity, and auspiciousness. Alongside these vibrant flowers is the resplendent sunbird, dazzling like the sun itself with its magnificent colorful plumage. It represents good fortune and auspiciousness.

In this piece, the blooming pomegranate flowers are vibrant and full, arranged beautifully on the branches in an artistic manner. A magnificent sunbird stands proudly on one of the branches, with its head held high. The combination of the flowers and the bird creates a scene that is fiery red, symbolizing good fortune and fulfillment.

Line Drawing

When drawing the outline, pay attention to the hierarchical relationship of the petals. Patiently draw each petal, which not only facilitates coloring later, but also makes it easier for us to draw each color block.

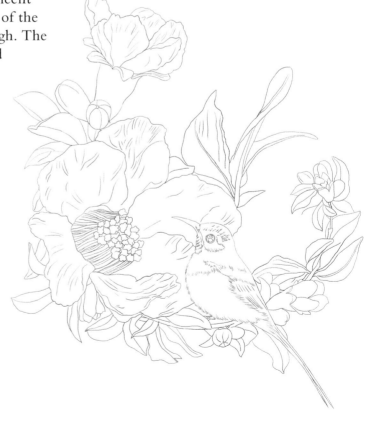

Colors Used

307 lemon yellow	309 medium yellow	314 yellowish orange
383 earth yellow	378 ocher	392 burnt sienna
316 reddish orange	318 scarlet red	321 bright red
329 peach red	325 rose red	347 sky blue
341 dark purple	343 ultramarine blue	370 yellowish green
366 grass green	361 phthalo green	359 emerald green
372 olive green	380 dark brown	399 black

Composition

Using the C-shaped composition, select an open pomegranate flower and a sunbird as the main subjects of the drawing. Then, add scattered flower buds of varying sizes, creating changes in the foreground and background as well as variations in size within the composition. The fiery red pomegranate flowers, paired with the sunbird in the same color scheme, create a vibrant color palette in the drawing. Emphasize the depiction of the large pomegranate flower and the sunbird to make them the focal points of the composition.

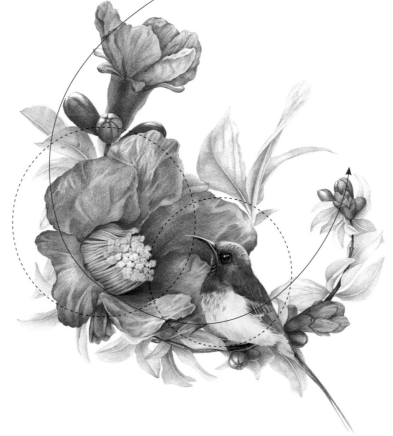

Steps

1

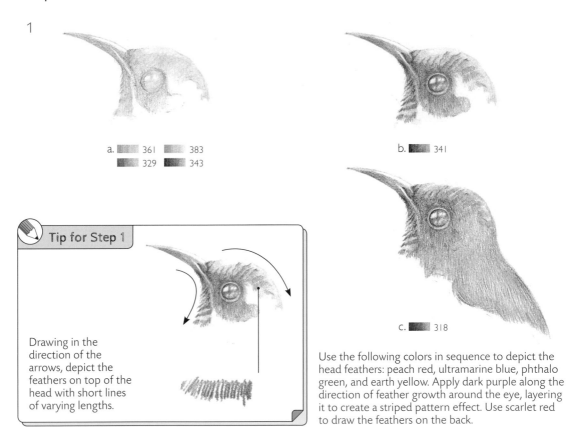

a. ■ 361 ■ 383
■ 329 ■ 343

b. ■ 341

c. ■ 318

Tip for Step 1

Drawing in the direction of the arrows, depict the feathers on top of the head with short lines of varying lengths.

Use the following colors in sequence to depict the head feathers: peach red, ultramarine blue, phthalo green, and earth yellow. Apply dark purple along the direction of feather growth around the eye, layering it to create a striped pattern effect. Use scarlet red to draw the feathers on the back.

2

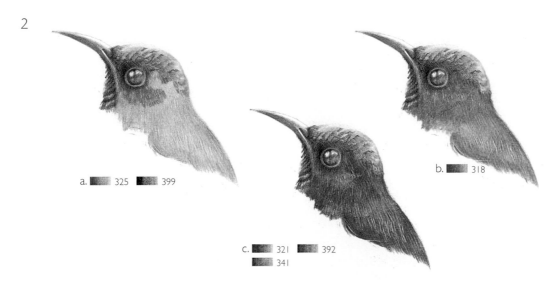

a. ■ 325 ■ 399

b. ■ 318

c. ■ 321 ■ 392
■ 341

Before coloring, use the tip of a mechanical pencil without lead refill to create some fine feather lines following the direction of growth. This way, when coloring, the indentations created by the lines will automatically remain uncolored, creating a highlighted effect. Next, use rose red to enrich the patterns on top of the head and below the beak. Then, use black to deepen the eye, and the feathers around the eye and below the beak. Next, following the direction of feather growth, use scarlet red, bright red, and burnt sienna to deepen the color of the feathers on the back. Add some dark purple at the transition between the back and the belly.

3

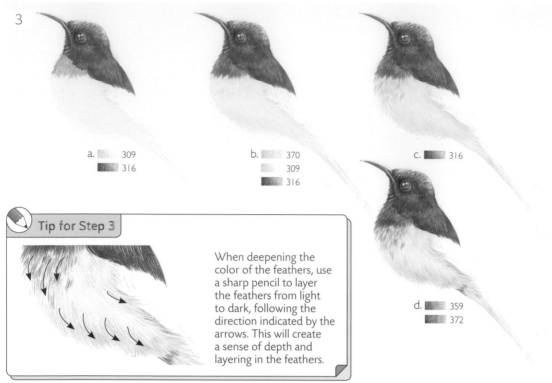

a. 309
 316

b. 370
 309
 316

c. 316

d. 359
 372

Tip for Step 3

When deepening the color of the feathers, use a sharp pencil to layer the feathers from light to dark, following the direction indicated by the arrows. This will create a sense of depth and layering in the feathers.

Start by evenly applying a layer of medium yellow and reddish orange to the feathers on the belly. Then, gently deepen the colors, and use slightly longer diagonal lines of yellowish green to darken the lower half of the belly. Finally, use reddish orange to draw the dotted patterns on the belly. Finally, use emerald green and olive green to deepen the shadows and the feathers at the transition with the wings, enhancing the three-dimensional effect of the belly.

Tips for Step 4

4

Shadowed part

The bird's body is overall circular, so the wing has curvature. The area circled in the image represents the shadowed part of the wing. When drawing, create a gradient color from the edge of the shadowed area towards the lighter part to depict the three-dimensional effect of the wing.

Heavy

Gentle

Apply lighter pressure with the pencil on the tip of the tail, creating a gradual fading effect. This helps reduce visual attraction and directs the focus towards the area where the bird interacts with the flower.

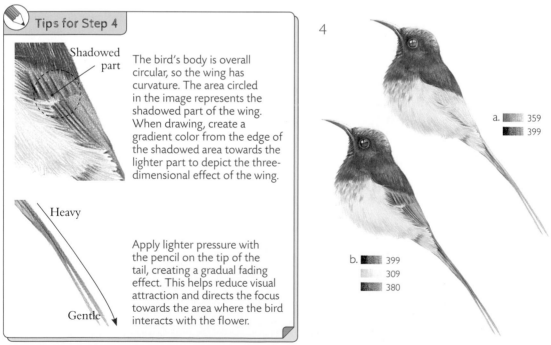

a. 359
 399

b. 399
 309
 380

Apply a base coat of emerald green to the wings and deepen the inner side of the tail. Then, gently differentiate the outline of the wing using black and lightly layer a touch of dark brown along the outline. Apply a hint of medium yellow to create highlights, creating a harmonious color connection between the wing and the belly.

5

a. ▦ 347

b. ▦ 380

Drawing the claws is quite simple. Start by evenly applying a coat of sky blue. Then, use dark brown to create a slight gradient along the edges, indicating the joints. Apply slightly more pressure on the edges closer to the body. Since the claws are very small, sharpen the pencil for better precision when drawing.

6

a. 307

b. ▦ 314

c. ▦ 318

For coloring the flower stamens, start by evenly applying a coat of lemon yellow as the base color. Then, use yellowish orange to outline the shape of the stamens and deepen the overall color and the shadowed areas of each filament with scarlet red. Apply slightly more pressure between the filaments to emphasize the gaps between them.

7

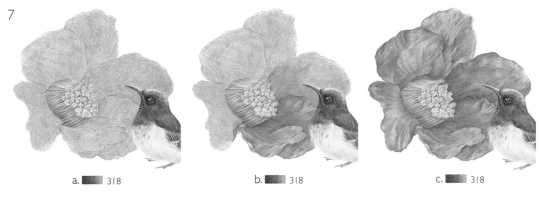

a. ▦ 318

b. ▦ 318

c. ▦ 318

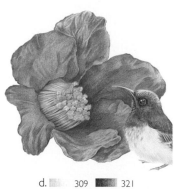

d. ▦ 309 ▦ 321

To draw the petals, start with scarlet red to depict the shape of the petals. Follow the contours of the petals to draw the folds and creases. When layering darker shades, leave some areas of the petals uncolored to create a sense of translucence. Finally, lightly apply a touch of medium yellow to the lighter areas of the petals.

✎ **Tip for Step 7**

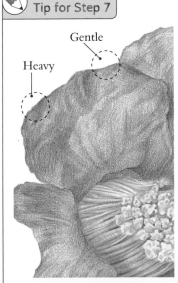

Gentle

Heavy

Apply slightly more pressure when depicting the edges of the petals, but also vary the intensity of the lines. Use slightly heavier lines at the points of curvature or where the petals overlap with each other. When depicting the small wrinkles on the pomegranate flower, be careful not to disrupt the overall light and dark relationships of the larger areas. After detailing the small wrinkles, you can adjust and harmonize the overall darker areas, while also emphasizing the details within those darker areas.

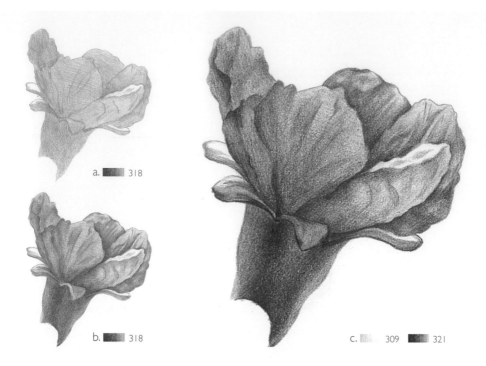

a. ▬ 318

b. ▬ 318

c. ▬ 309 ▬ 321

To color the larger pomegranate flower on the top, follow a similar approach. Start with scarlet red to outline the general areas of light and dark on the flower. Then, use bright red to deepen the dark areas and lightly apply a touch of medium yellow to the light areas, enhancing the overall contrast of light and dark. Pay attention to leaving some areas uncolored to portray the transparency of the petals, creating a sense of translucency.

Tip for Step 8

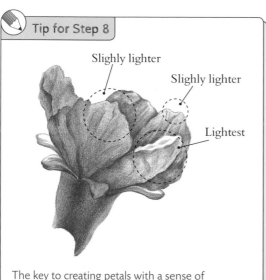

Slighly lighter

Slighly lighter

Lightest

The key to creating petals with a sense of transparency lies in how you handle the use of blank space or areas left uncolored. In the areas of light and dark on the petals, it is important to leave some space uncolored. However, the intensity of the blank space can vary. The brighter the blank space, the stronger the sense of transparency. In addition, when surrounded by darker petals, the contrast between light and dark becomes even stronger.

9

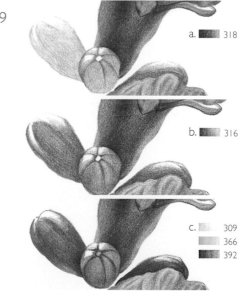

a. ▬ 318

b. ▬ 316

c. ▬ 309
▬ 366
▬ 392

Begin with scarlet red and reddish orange to depict the inherent color and three-dimensional quality of the flower buds. Leave out areas for highlights to convey the smooth texture of the buds. Apply a layer of medium yellow to the highlighted areas of the flower buds, and lightly add a touch of grass green at the top of the smaller buds. Finally, use burnt sienna to deepen the shadows between the flower buds.

10

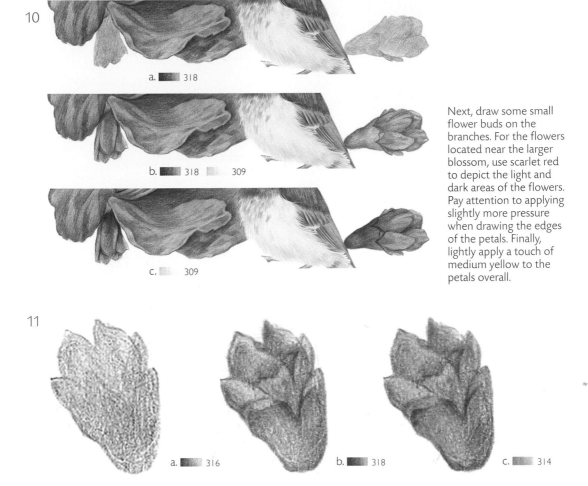

a. � 318

b. ▪ 318 ▪ 309

c. ▪ 309

Next, draw some small flower buds on the branches. For the flowers located near the larger blossom, use scarlet red to depict the light and dark areas of the flowers. Pay attention to applying slightly more pressure when drawing the edges of the petals. Finally, lightly apply a touch of medium yellow to the petals overall.

11

a. ▪ 316 b. ▪ 318 c. ▪ 314

The method for drawing the small flowers on the branches is the same. Start by applying a base coat of reddish orange, then use scarlet red to depict the layers of the petals, indicating the front and back petals. Finally, lightly layer a touch of yellowish orange on top.

12

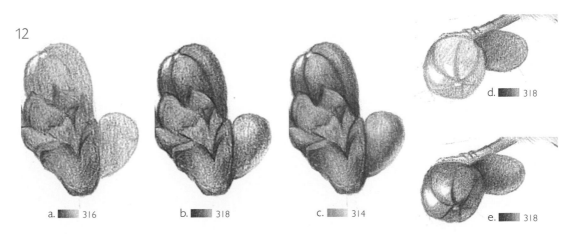

a. ▪ 316 b. ▪ 318 c. ▪ 314 d. ▪ 318 e. ▪ 318

Although the drawing method and color usage for depicting flower buds on branches are generally the same, in order to make the colors in the picture more vibrant, we can subjectively adjust the color processing to create differentiation. Some can have a yellowish tint, while others can have a reddish tint. There should also be variations in shades. The elliptical shaped flower buds should have strong highlights as well.

13

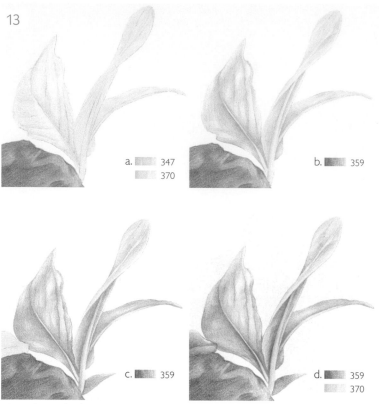

a. ▮▮▮ 347
 ▮▮▮ 370

b. ▮▮▮ 359

c. ▮▮▮ 359

d. ▮▮▮ 359
 ▮▮▮ 370

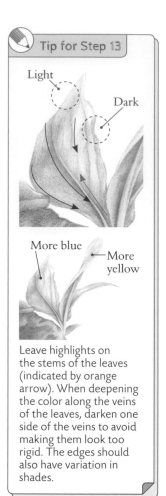

Tip for Step 13

Light

Dark

More blue

More yellow

Leave highlights on the stems of the leaves (indicated by orange arrow). When deepening the color along the veins of the leaves, darken one side of the veins to avoid making them look too rigid. The edges should also have variation in shades.

Next, depict the leaves. Start by applying a base color of sky blue and yellowish green. Then, overlay the leaf color with emerald green along the edges and veins of the leaves. Gradually deepen the color along the veins and add a touch of yellowish green to increase saturation. The colors of the leaves toward the back should be lighter, and the strokes should be slightly blurred.

14

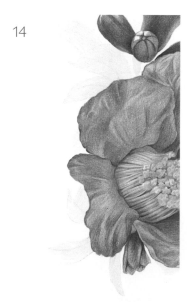

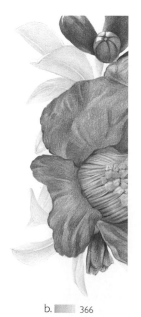

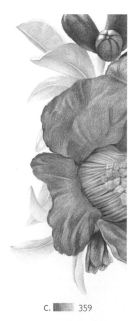

a. ▮▮▮ 370

b. ▮▮▮ 366

c. ▮▮▮ 359

For the leaves on the left side of the picture, start by applying a light layer of yellowish green, followed by grass green and emerald green to depict the three-dimensional effect and the layers of the leaves.

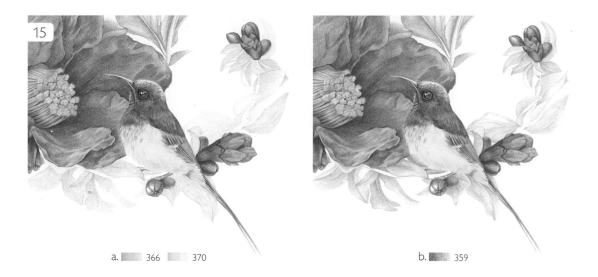

a. ▓▓ 366 ░ 370

b. ▓▓ 359

Draw the leaves at the bottom of the picture. With the overshadowing effect of the flowers, the leaves are in the shadowed area, so the colors should be darker. Start by using yellowish green and grass green to establish the basic light and shadow of the leaves. Then, use emerald green to deepen the colors between the leaves, making the contours of the leaves more defined.

a. ▓▓ 378 ▓▓ 380 380 ░ 359

b. ▓▓ 392 ▓▓ 321 ▓▓ 399

Finally, use ocher and dark brown to depict the branch. Then, use emerald green to darken the shadowed areas of the leaves as a whole, creating the areas of strong color on the leaves. Next, use a sharp burnt sienna pencil to deepen the area where the flower stamens meet the petals, transitioned with bright red. Enhance the darkest parts of the other flowers to adjust the overall effect of the composition. Use black to emphasize the dark parts of the sunbird's beak, eye, and other dark areas.

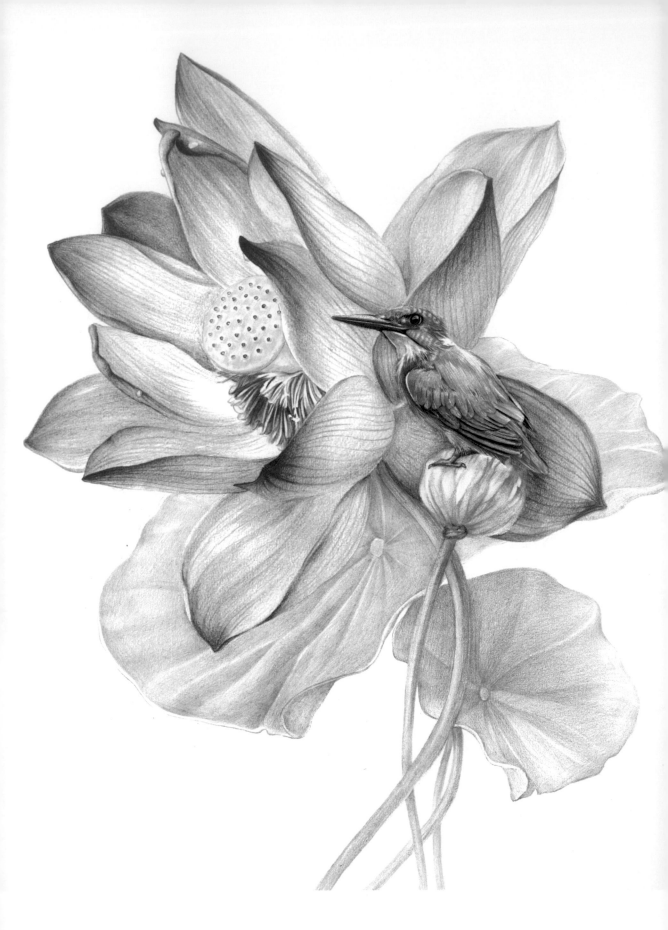

Kingfisher and Lotus Flower

When lotus flowers bloom in summer, layers of graceful lotus leaves stand peacefully on the water's surface. The lotus flowers unfurl one by one, facing the radiant sun, as their pink petals stretch out freely. The lotus flower is one of the ten most loved traditional flowers in China, symbolizing purity, nobility, and steadfastness. The blooming lotus attracts a water sprite—the kingfisher—to perch on it. Its colorful feathers are vibrant and magnificent, symbolizing good fortune and happiness.

In this piece, round turquoise green lotus leaves cradle a tall and graceful lotus flower. Perched delicately atop it is an adorable kingfisher. Its splendid blue feathers complement the enchanting lotus petals, weaving together a lovely serene summer scene.

Line Drawing

When drawing the outline, start by establishing the position of each object. Then, use long lines to precisely refine the shape of the petals, paying attention to the elegance of the lines. Gradually add details such as the texture on the petals and the direction of the bird's feathers.

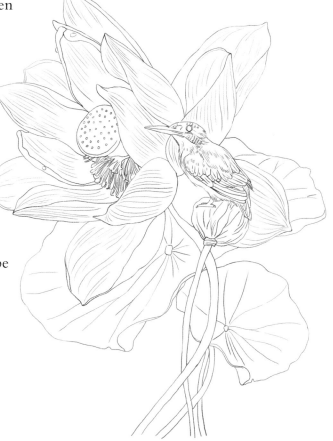

Colors Used

307 lemon yellow	314 yellowish orange	316 reddish orange
318 scarlet red	319 pink	329 peach red
325 rose red	327 eosin	339 pink purple
341 dark purple	344 Prussian blue	343 ultramarine blue
345 lake blue	347 sky blue	370 yellowish green
366 grass green	359 emerald green	357 blue green
378 ocher	392 burnt sienna	396 gray
399 black		

Composition

The combination of pink lotus flower and jewelry-blue kingfisher creates a contrast of warm and cool tones in the piece. The green leaves play a neutralizing role, bringing harmony to the composition amid the contrast. Exaggerate the proportion of the lotus flower to create a dreamy, ethereal beauty in the composition.

Place emphasis on the lotus flower and the kingfisher, allowing the main focus of the piece to be more concentrated.

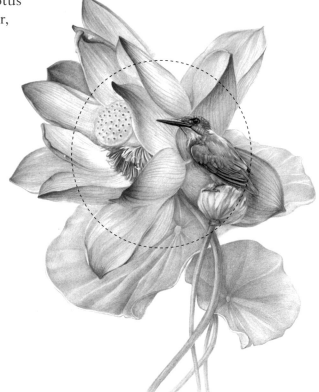

Steps

1

a. ▰▰ 396 ▰▰ 347 b. ▰▰ 399 c. ▰▰ 345

With a sharp gray pencil, apply the color for the beak and use black to darken the shadowed areas. Apply slightly more pressure between the beak's gaps. For the feathers on the top of the head, apply a base color of sky blue and use short slanted strokes with lake blue to create striped patterns.

2

a. ▰▰ 314 b. ▰▰ 314 c. ▰▰ 392

Tip for Step 2

Control the pressure of the pencil, and use a little more force around the edges of the head and the eye, so that the outline of the feathers in different areas of the bird can be more clearly defined.

Use yellowish orange and burnt sienna to depict the feathers on the abdomen, paying attention to the direction of the feathers' growth. Apply more pressure where the feathers meet the wing to accentuate the outline of the wings.

3

a. ▰▰ 347 b. ▰▰ 345

c. ▰▰ 344 ▰▰ 378 d. ▰▰ 399 ▰▰ 318 ▰▰ 341

For the feathers on the back, wings, and tail, start by applying a base layer of sky blue to the entire area. Allow some bright blue to show through for the highlighted feathers. Then, gradually deepen the colors using lake blue, Prussian blue, and dark purple. The gaps between the wing feathers are deepened using ocher and black. The wing contours can have multiple layers of color overlapped. To finish, scarlet red is overlaid on the feathers in the chest to enhance the color contrast of the bird's plumage.

4

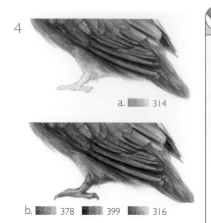

a. ▮▮▮ 314

b. ▮▮▮ 378 ▮▮▮ 399 ▮▮▮ 316

Draw the base color of the claws with yellowish orange, then gently outline and deepen the edges with ocher and reddish orange. Finally, use a sharp black pencil to draw the nails.

🖉 Tips for Step 4

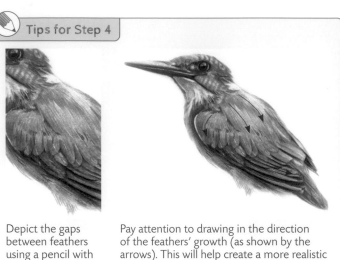

Depict the gaps between feathers using a pencil with darker colors and short lines.

Pay attention to drawing in the direction of the feathers' growth (as shown by the arrows). This will help create a more realistic representation of the texture of the feathers.

5

a. ▮▮ 370

b. ▮▮ 366

c. ▮▮ 359
 307

d. ▮▮ 392

e. ▮▮ 359

🖉 Tip for Step 5

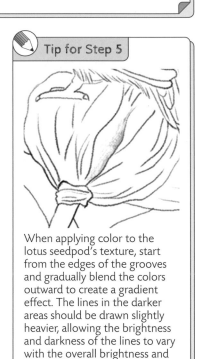

When applying color to the lotus seedpod's texture, start from the edges of the grooves and gradually blend the colors outward to create a gradient effect. The lines in the darker areas should be drawn slightly heavier, allowing the brightness and darkness of the lines to vary with the overall brightness and darkness of the lotus seedpod.

The lotus seedpod can be portrayed using yellowish green, grass green, and emerald green in sequence to depict its three-dimensional appearance. Slightly darken the grooves in the darker areas of the lotus seedpod using emerald green, and add a touch of lemon yellow on the brighter areas. Then gently layer a little burnt sienna around the claw to add a touch of warmth amidst the cool tones, portraying the impending yellowing of the lotus seedpod.

6

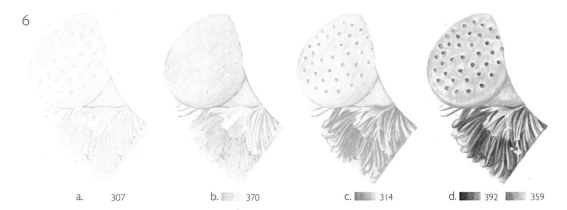

a. 307 b. 370 c. 314 d. 392 359

The lotus seedpod and stamen in the lotus flower should be outlined first using lemon yellow and yellowish green. Then use yellowish orange to depict distinct stamens, and use dotted lines to indicate the positions of the lotus seeds. Finally, deepen the surface of the lotus seedpod with emerald green, and use burnt sienna to deepen the inner part of the stamens along their edges. Gently deepen the color of the lotus seeds as well.

7

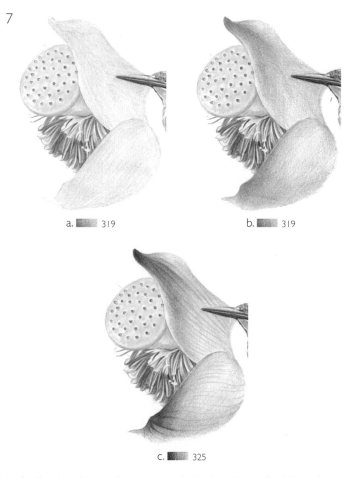

a. 319 b. 319

c. 325

Start by drawing the two foremost petals. Begin with gentle pink strokes to depict the three-dimensional aspect of the petals. Apply slightly heavier strokes at the tips of the petals. Then, with a sharp rose red pencil, delicately draw the slender veins on the petals, gradually darkening the tips of the petals.

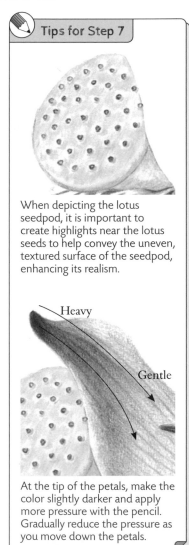

Tips for Step 7

When depicting the lotus seedpod, it is important to create highlights near the lotus seeds to help convey the uneven, textured surface of the seedpod, enhancing its realism.

Heavy

Gentle

At the tip of the petals, make the color slightly darker and apply more pressure with the pencil. Gradually reduce the pressure as you move down the petals.

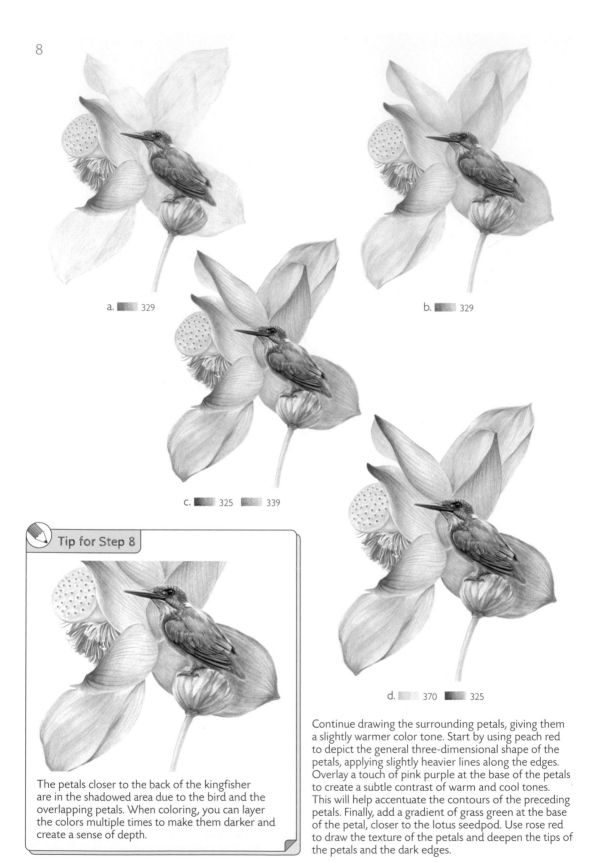

a. ▮▮ 329

b. ▮▮ 329

c. ▮▮ 325 ▮▮ 339

d. ▮▮ 370 ▮▮ 325

Tip for Step 8

The petals closer to the back of the kingfisher are in the shadowed area due to the bird and the overlapping petals. When coloring, you can layer the colors multiple times to make them darker and create a sense of depth.

Continue drawing the surrounding petals, giving them a slightly warmer color tone. Start by using peach red to depict the general three-dimensional shape of the petals, applying slightly heavier lines along the edges. Overlay a touch of pink purple at the base of the petals to create a subtle contrast of warm and cool tones. This will help accentuate the contours of the preceding petals. Finally, add a gradient of grass green at the base of the petal, closer to the lotus seedpod. Use rose red to draw the texture of the petals and deepen the tips of the petals and the dark edges.

9

a. ▬▬ 329

b. 307

c. ▬ 325

d. ▬▬ 327

e. ▬▬ 325

Tip for Step 9

Light

Dark

Dark

Utilize contrast in light and dark tones to create a sense of distance between the front and back petals. Pay attention to applying heavier pressure with the pencil at the tips of the petals.

For the petals in the distant left side, start by using peach red to outline the shape of the petals. Then, gently overlay a touch of lemon yellow at the bottom of the petals to complement the color of the stamens. Next, deepen the color of the petals using rose red and eosin, differentiating the front and back petals at the edges.

10

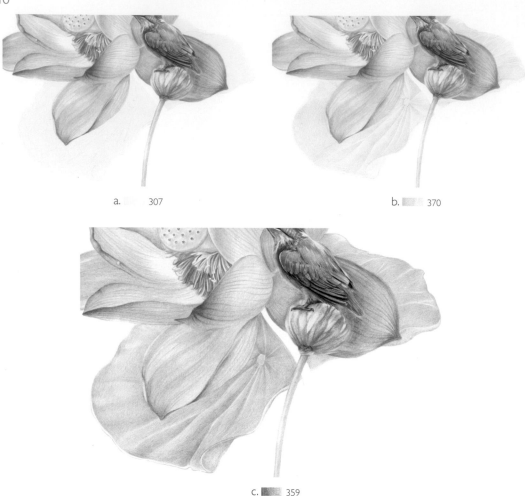

a.　307

b.　370

c.　359

Next, draw the lotus leaf on the left side. Start by evenly applying a layer of lemon yellow overall to the leaf, giving it a tender yellow effect. Then, use yellowish green to deepen the color along the veins of the leaf. Finally, add another layer of color using emerald green along the veins to enhance the leaf's appearance.

Tips for Step 10

Gentle

Heavy

More yellowish

Greener

When coloring the lotus leaf, follow the direction of the veins with your pencil. Apply gentle pressure to slightly darken the veins. However, keep in mind that the contour of the veins should also have variations in intensity, so as to avoid appearing too rigid.

For the overall color of the leaf, make the brighter areas slightly more yellowish, while the darker areas should have a slightly greener hue.

11

a. ▮▮▮ 343 b. ▮▮▬ 359 c. ▮▮▬ 357

Please note that the lotus leaf in the lower right corner is in the shadow of the preceding leaf, so the color of the leaf should be handled with a cooler tone. Start by applying a layer of ultramarine blue to the leaf. Then, use emerald green and blue green to deepen the color along the veins. Be sure to leave some lighter areas to allow the underlying ultramarine blue to show through. Deepen the central part of the leaf to create a concave impression.

12

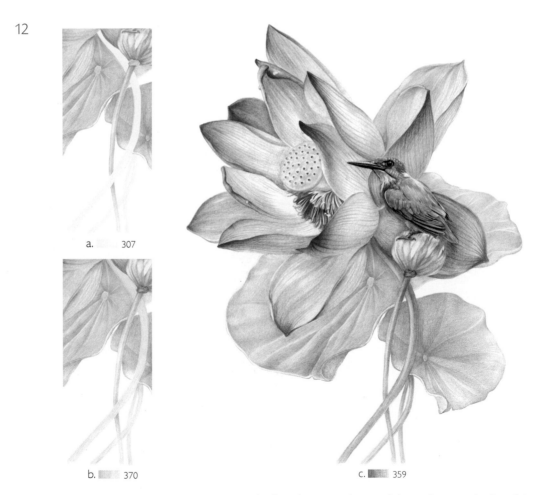

a. ▬ 307

b. ▬▬ 370 c. ▮▮▬ 359

Finally, draw the flower stems. Use lemon yellow and yellowish green to layer and depict the natural color of the stems. Then, use emerald green to deepen the shadows and create a sense of three dimensionality in the stems. Lastly, use emerald green to deepen the edges of the lotus leaves and the areas where they connect with the petals, enhancing the overall contour and spatial relationship of the petals.

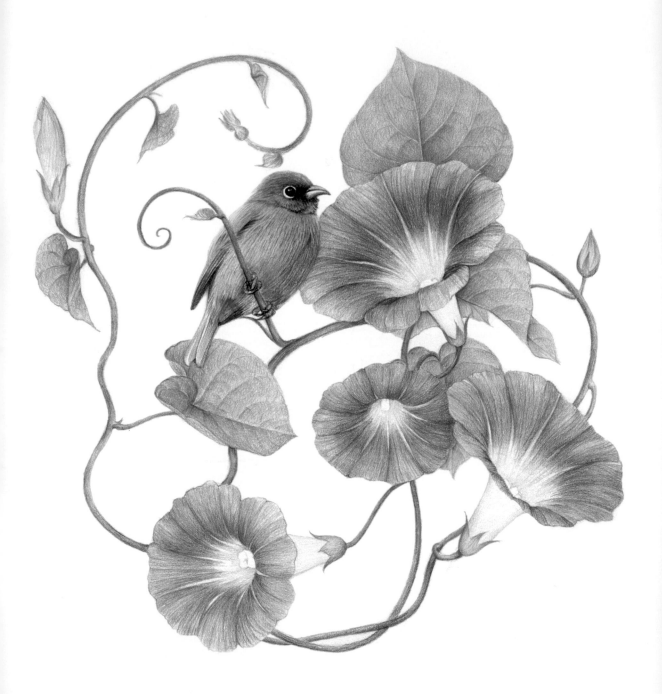

Rosefinch and Morning Glory

A beautiful Chinese folk legend, tells of a celestial fairy and a human cowherd fell in love. They eventually transformed into the Vega and the Altair, reuniting in the heavens. Morning glory is said to be the celestial robe woven by the fairy for her cowherd lover in the legend.

Morning glories always bloom in the early morning. Their hexagonal blossoms resemble delicate little trumpets, and they shine brightly in the sunlight, displaying vibrant, captivating colors. Because the slender vines of the morning glory are not afraid of wind and rain, displaying great vitality and resilience, they are also associated with diligence and strength. The plumage of the rosefinch's belly resembles a blooming rose in the morning, exuding a charming and delightful beauty that captivates the heart.

In this piece, the morning glories bloom vigorously, creating a lively, vibrant scene. The flower vines intertwine and playfully frolic, even drawing the rosefinch to join in the excitement.

Line Drawing

You can begin by using a large square to establish the overall composition of the piece. Then, draw the main vine and determine its direction of entwinement. Next, decide on the sizes and positions of the flowers and the bird. Finally, refine and add detail to each element of the composition, bringing their shapes to life.

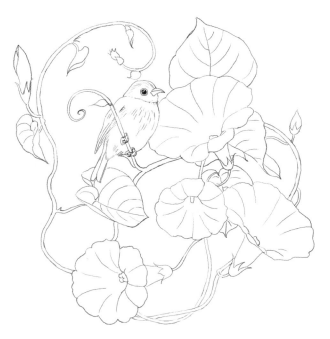

Colors Used

307 lemon yellow	309 medium yellow	314 yellowish orange
316 reddish orange	329 peach red	333 red purple
337 purple	392 burnt sienna	347 sky blue
354 light blue	345 lake blue	343 ultramarine blue
366 grass green	359 emerald green	372 olive green
396 gray	399 black	

Composition

The overall color palette of the piece leans toward cool tones, creating a sense of refreshing summer. The addition of a vibrant color to the bird's belly adds a touch of interest to the composition. The entire composition follows an oval-shaped structure, with the vine winding and entwining within the boundaries of the oval. The bird and flower, enclosed by a dashed line, serve as the focal points of the composition and should be emphasized in the depiction.

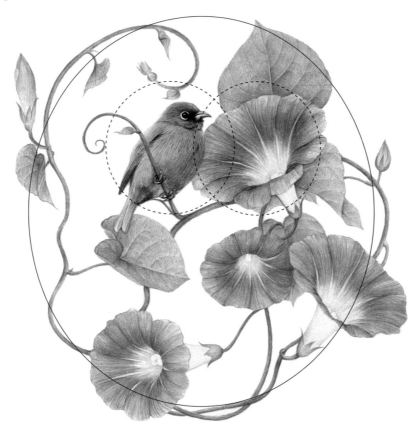

Steps

1

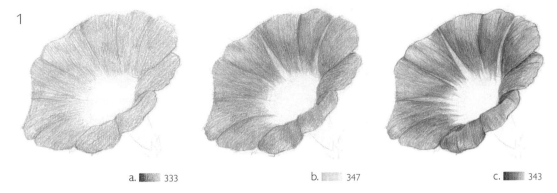

a. ▰▰ 333 b. ▰ 347 c. ▰▰ 343

Begin by drawing the first blue purple morning glory on the right side of the bird. Start by applying a base color of red purple to the petals, and then layer a coat of sky blue on top. This will establish the foundation for the flower's color tone. Make sure to follow the direction of the petal's growth with your lines, being meticulous and patient when layering the colors to ensure a smooth transition between shades. Finally, with a sharp ultramarine blue pencil, depict the darker tones of the flower petals, adding texture details to the petals.

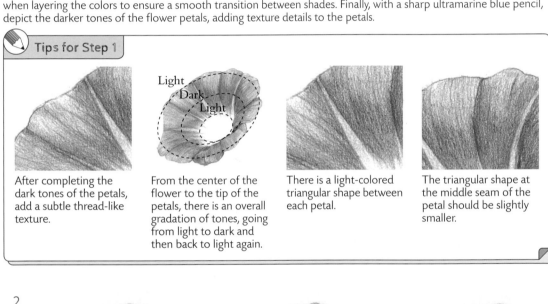

Tips for Step 1

Light
Dark
Light

After completing the dark tones of the petals, add a subtle thread-like texture.

From the center of the flower to the tip of the petals, there is an overall gradation of tones, going from light to dark and then back to light again.

There is a light-colored triangular shape between each petal.

The triangular shape at the middle seam of the petal should be slightly smaller.

2

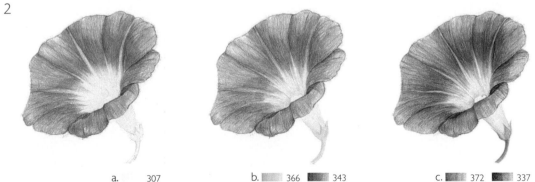

a. 307 b. ▰ 366 ▰ 343 c. ▰ 372 ▰ 337

Proceed by coloring the center of the flower with lemon yellow and grass green, leaving the stamen area blank. To avoid triangular shapes between the petals that are too bright, apply some ultramarine blue to slightly darken the area and create a gentle transition from the petal color toward the center of the flower. Finally, use olive green to deepen the color of the receptacle and further deepen the outline of the stamen. Overlay the petals with purple to deepen the tone.

3

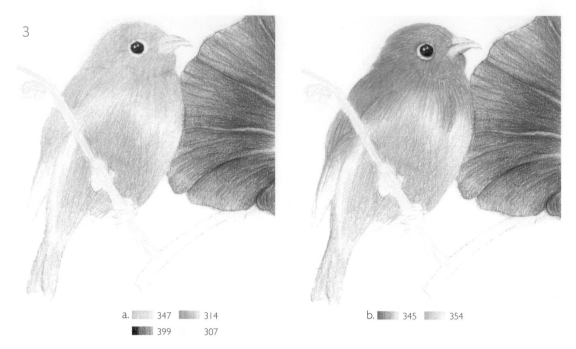

a. ▨ 347 ▨ 314
▨ 399 307

b. ▨ 345 ▨ 354

Apply sky blue, yellowish orange, black, and lemon yellow as base colors to the various parts of the bird and branches. Make sure that the sky blue and yellowish orange do not come into contact with each other. Further deepen the head, wing, and feathers with lake blue, then layer on light blue to make the blue more vibrant.

4

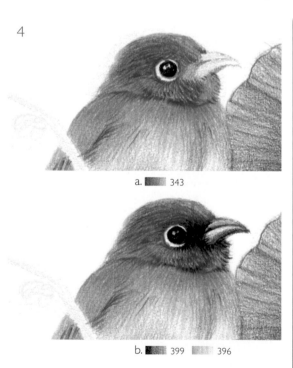

a. ▨ 343

b. ▨ 399 ▨ 396

Use ultramarine blue to depict the dark feathers around the eye, neck, and under the wing. Then, use black to draw the black feathers between the eye and the beak. Use gray to deepen the shadowed areas of the bird's beak and use black to outline the edges of the shadowed parts of the beak.

✏️ Tip for Step 4

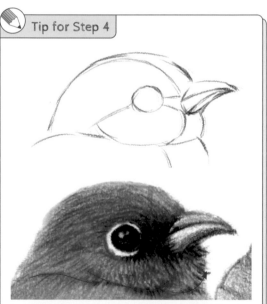

In addition to the natural variations in fur colors, the depth and shading of the head's colors are closely connected. Once you draw the projection of the face onto the neck (as indicated by the red arrows), the three dimensionality of the bird's head becomes immediately apparent. Due to the tightly compressed nature of the head, the short feathers on the face are divided into several layers. By capturing this characteristic, you can create a lively, realistic depiction of the bird.

5

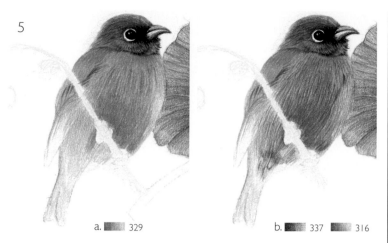

a. ▆ 329 b. ▆ 337 ▆ 316

Overlay peach red on the yellowish orange feathers of the abdomen and ensure a smooth transition between the blue and yellowish orange on the chest. Then, extend the blue feathers on the chest toward the abdomen with purple. Deepen the color of the abdominal feathers with reddish orange, making sure to avoid overlapping the purple and reddish orange lines as much as possible.

6

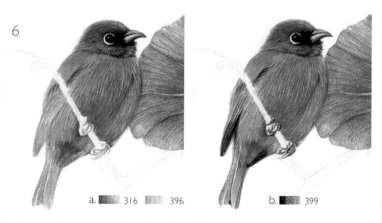

a. ▆ 316 ▆ 396 b. ▆ 399

Begin by using gray to darken the side of the bird's abdomen that is closer to the flower to create a sense of space and separation between the flower and the bird. Next, use gray to fill in the remaining white spaces on the wings, tail, and claws. Then, use black to deepen the shading, using a fine tipped pencil to draw the gaps between overlapping feathers. The darker areas under the wings should be even deeper, and the shapes of the tail feathers and claws should be clearly outlined using black.

7

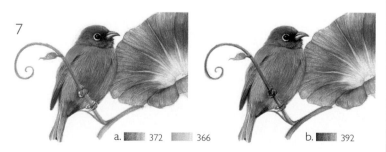

a. ▆ 372 ▆ 366 b. ▆ 392

Start by applying a layer of grass green to the small branches, then overlay it with olive green to deepen the color. Next, use burnt sienna to add to the edges and shadowed areas of the branches. The intertwining of green and burnt sienna is characteristic of vines.

Tips for Step 5

Keep yellow and blue separate, as they can create green when layered together.

The bird's abdomen is in shades of reddish orange, but it should not be directly drawn with reddish orange, as it can appear muddy when layered with blue. However, through experimentation, you will find that layering peach red over medium yellow can create reddish orange, and peach red layered with blue can produce purple. Using blue, peach red, and medium yellow, you can achieve a natural blend of blue and reddish orange in the drawing.

8

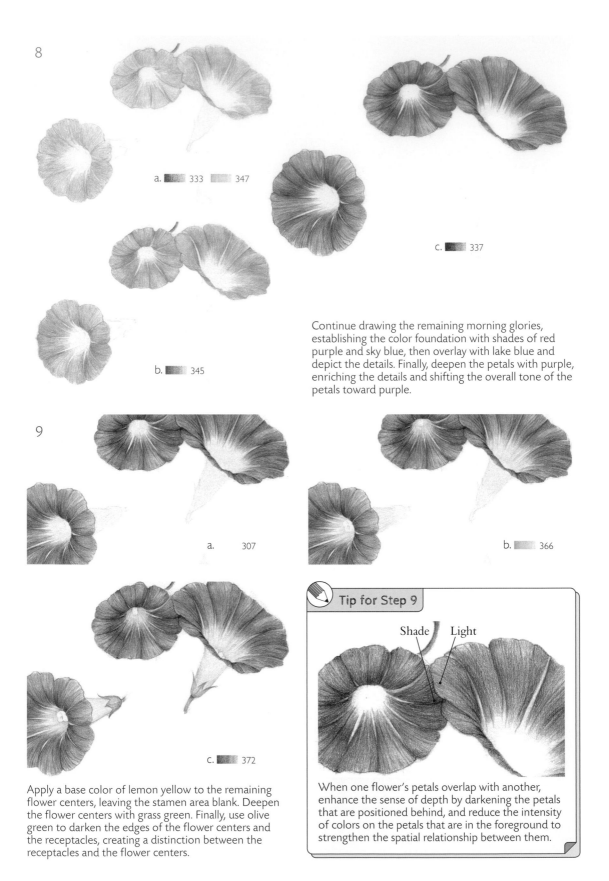

a. ▪▪▪▪ 333 ▪▪▪ 347

c. ▪▪▪ 337

b. ▪▪▪ 345

Continue drawing the remaining morning glories, establishing the color foundation with shades of red purple and sky blue, then overlay with lake blue and depict the details. Finally, deepen the petals with purple, enriching the details and shifting the overall tone of the petals toward purple.

9

a. 307

b. ▪▪ 366

Tip for Step 9

Shade Light

c. ▪▪▪ 372

Apply a base color of lemon yellow to the remaining flower centers, leaving the stamen area blank. Deepen the flower centers with grass green. Finally, use olive green to darken the edges of the flower centers and the receptacles, creating a distinction between the receptacles and the flower centers.

When one flower's petals overlap with another, enhance the sense of depth by darkening the petals that are positioned behind, and reduce the intensity of colors on the petals that are in the foreground to strengthen the spatial relationship between them.

10

a. �■■ 329 b. ■■■ 337

The depiction of a flower bud is relatively simple. Start by applying a base color of peach red to the bud. Then, use purple to darken the tip and edges of the bud, gently transitioning toward lighter shades.

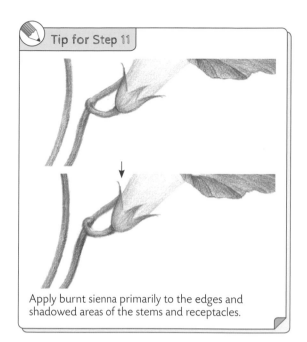

Tip for Step 11

Apply burnt sienna primarily to the edges and shadowed areas of the stems and receptacles.

11

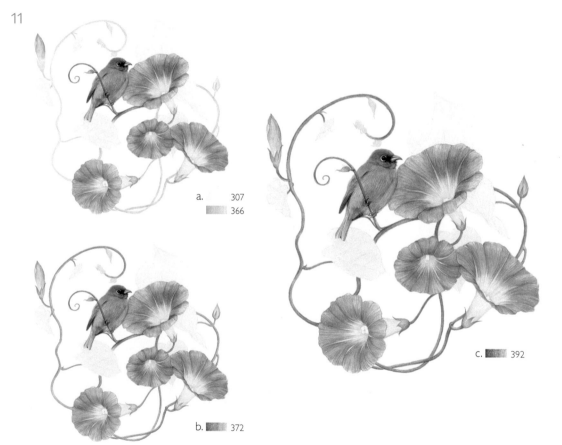

a. ▬▬ 307
 ▬▬ 366

b. ■■ 372

c. ▬▬ 392

On all the remaining vines and leaves, uniformly apply a base color of lemon yellow. Then, individually depict the vines, focusing on their distinct characteristics. Start by overlaying grass green on the vines and receptacles. Then, use olive green to deepen the color of the vines and add shadows. Next, layer burnt sienna onto the edges and shadowed areas of the vines. Burnt sienna not only deepens the color but also represents the inherent color of the vines.

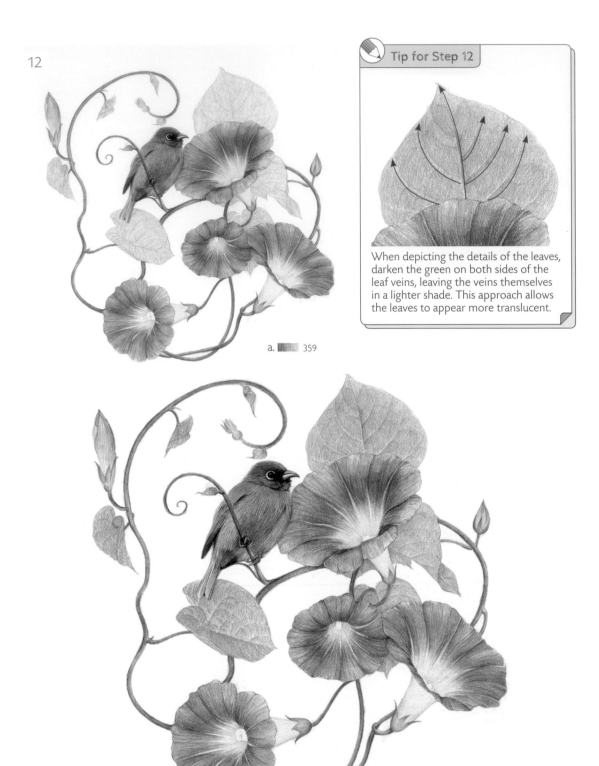

12

Tip for Step 12

When depicting the details of the leaves, darken the green on both sides of the leaf veins, leaving the veins themselves in a lighter shade. This approach allows the leaves to appear more translucent.

a. ▩▩ 359

b. ▩▩ 359 ▩ 309

Overlay a smooth and even layer of emerald green on the leaves, ensuring a clean, uniform appearance. Redraw the shape of the leaf veins to make them more defined. Further darken the leaves as a whole, paying special attention to deepening the areas around the leaf veins. Create a more refined color transition. Then, layer medium yellow on top to create a warm tone.

13

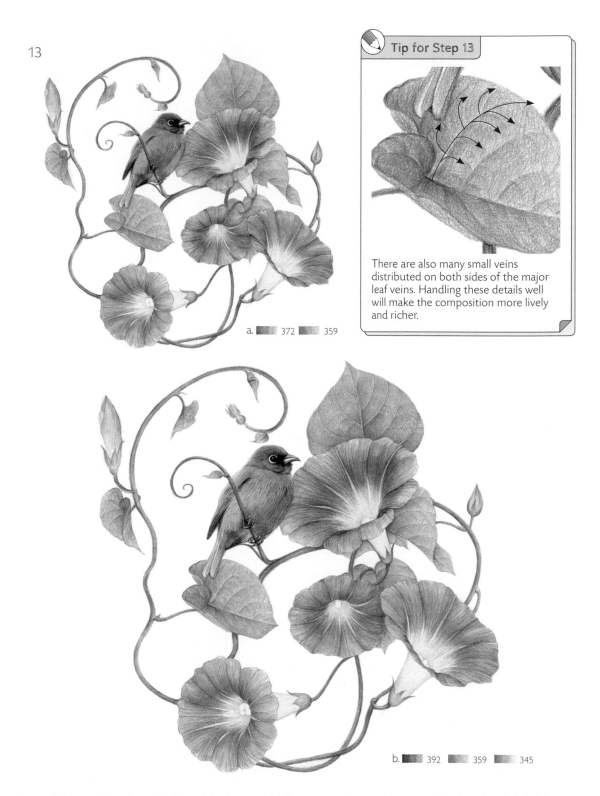

Tip for Step 13

There are also many small veins distributed on both sides of the major leaf veins. Handling these details well will make the composition more lively and richer.

a. ▨ 372 ▨ 359

b. ▨ 392 ▨ 359 ▨ 345

Overall, deepen the veins and edges of the leaves with olive green and emerald green. Make the color slightly lighter for the leaves positioned toward the back. Next, use burnt sienna to outline the leaf veins near the petiole. Then, use emerald green to further darken the darker areas of the leaves. Finally, overlay a small amount of lake blue on the petals to fine-tune their hue and shift them slightly toward blue, and create a more harmonious color palette in the composition.

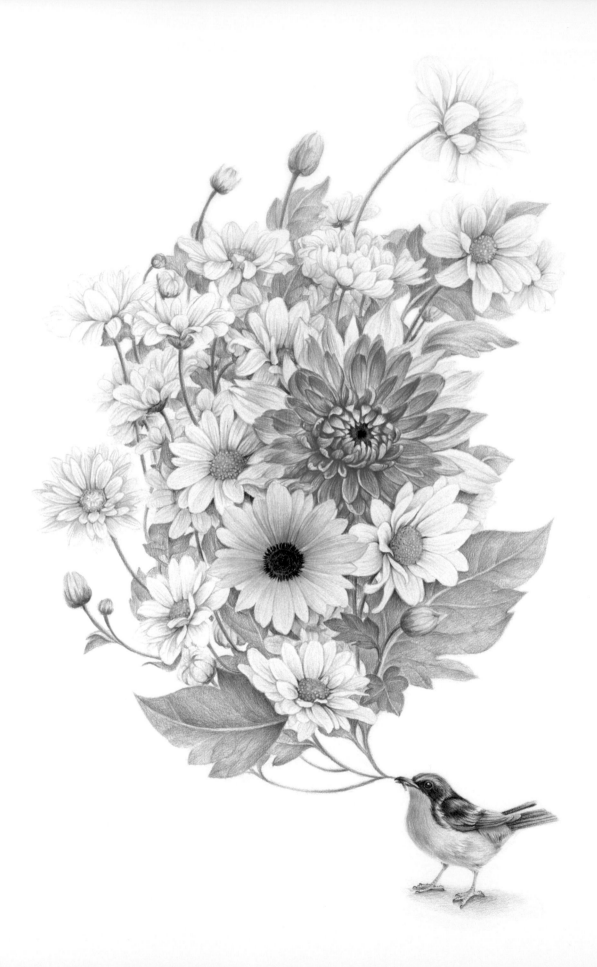

Narcissus Flycatcher and Chrysanthemum

Chrysanthemums are an autumn blooming flower which comes in various types with abundant colors. The white ones sparkle like snow, while the yellow ones shine like gold. There are also lovely delicate pink chrysanthemums. The chrysanthemum is one of the top favorite traditional flowers in China, symbolizing nobility, longevity, and resilience. Appreciating chrysanthemums and drinking chrysanthemum wine in autumn are enduring folk customs deeply rooted in Chinese culture. During this time, the narcissus flycatcher migrates to warmer regions, preparing for the winter. These adorable little creatures have clear, melodious songs, and they are capable of imitating the calls of other birds.

In this piece, a small narcissus flycatcher is carrying a bundle of flourishing chrysanthemums. The golden autumn chrysanthemums beautifully complement the bird's bright yellow feathers, celebrating the arrival of autumn.

Line Drawing

After drawing the outline of the bird, begin from its beak and create an upward curving droplet shape to represent the general range of the clustered flowers. Next, outline the flowers in the foreground and then add the details of the petals. Finally, add the remaining flowers and leaves that are partially hidden. The layering of the petals can be handled flexibly but should be done in a way that fits the scene.

Colors Used

307 lemon yellow	309 medium yellow	314 yellowish orange
316 reddish orange	318 scarlet red	321 bright red
329 peach red	392 burnt sienna	378 ocher
380 dark brown	387 yellowish brown	359 emerald green
372 olive green	395 light gray	396 gray
399 black		

Composition

The entire composition follows an arch-shaped arrangement, and the distribution of visual weight is consistent with the arch. The orientation of the flowers should radiate outward from the center, with the topmost flowers curving backward. This is key to balancing the visual weight in the composition. The main color scheme of the composition consists of highly saturated yellow and orange tones. The green leaves have a lower saturation to create a softer overall effect, while the flower centers and the bird's back exhibit a stronger tonal contrast. The dotted line encircles the visual focal points of the composition. When applying colors, special attention should be given to these areas to ensure their prominence in the piece.

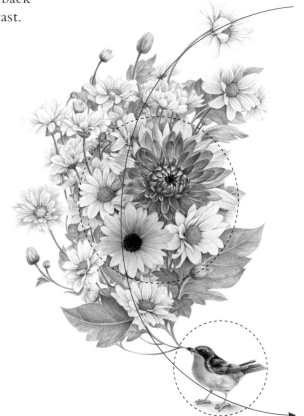

Steps

1

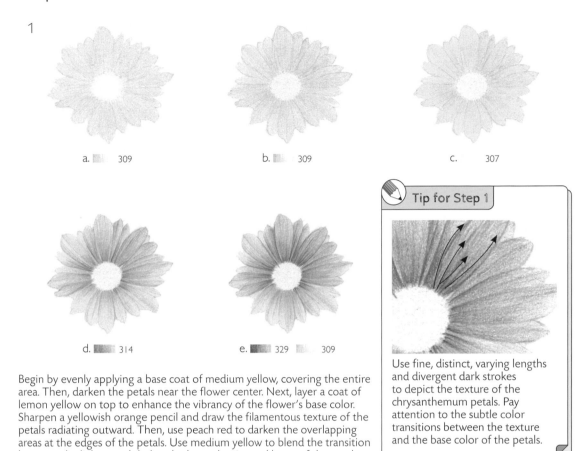

a. ▨ 309 b. ▨ 309 c. 307

d. ▦ 314 e. ▦ 329 ▪ 309

Tip for Step 1

Use fine, distinct, varying lengths and divergent dark strokes to depict the texture of the chrysanthemum petals. Pay attention to the subtle color transitions between the texture and the base color of the petals.

Begin by evenly applying a base coat of medium yellow, covering the entire area. Then, darken the petals near the flower center. Next, layer a coat of lemon yellow on top to enhance the vibrancy of the flower's base color. Sharpen a yellowish orange pencil and draw the filamentous texture of the petals radiating outward. Then, use peach red to darken the overlapping areas at the edges of the petals. Use medium yellow to blend the transition between the lighter and darker shades at the tips and bases of the petals.

2

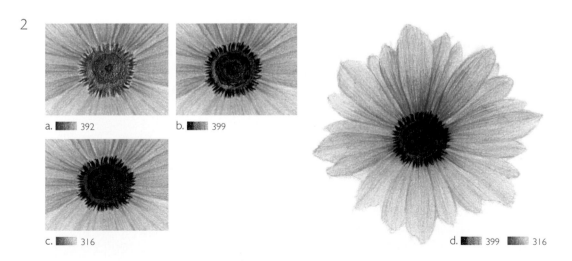

a. ▦ 392 b. ▦ 399

c. ▦ 316

d. ▦ 399 ▦ 316

Start by applying a base color of burnt sienna to the flower centers, and deepen the darker areas. Then, use black to draw short stamens in the outer ring and add grains in the center. Finally, apply an overall coat of reddish orange to make the flower centers more vibrant. Lastly, use black to further darken the shadowed areas of the flower centers. Use reddish orange to deepen the petals near the short stamens. This will ensure that the flower center feels grounded.

3

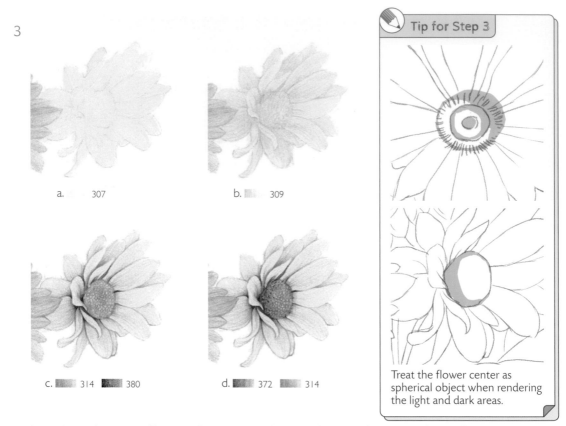

a.　　307

b.　　309

c.　　314　　380

d.　　372　　314

Treat the flower center as spherical object when rendering the light and dark areas.

Start by applying a base coat of lemon yellow to the small chrysanthemum. Then, use medium yellow to deepen the petals and the flower center. Next, use yellowish orange to darken the shadowed areas where the petals overlap and create a sense of graininess in the flower center with dense small circles. Next, use dark brown to emphasize the dark crevices. Finally, use a combination of olive green and yellowish orange to deepen the grains in the darker areas of the flower center.

4

a.　　309　　316

b.　　309

Start by evenly applying a base coat of medium yellow. Then, layer on top with reddish orange to distinguish the central red petals. Finally, apply another overall layer of medium yellow to make the flower's color more vibrant.

5

a. ■■■ 318

b. ■■■ 318

c. ■■■ 321 ▨ 309

Begin by using scarlet red to draw a minimal amount of filamentous texture on the outermost petals. Then, deepen the tone of the red petals and enhance the details. Start from the outer edges and gradually work toward the center. Next, use bright red to darken the shadowed areas of the curled smaller petals near the flower center, enriching the color hierarchy.

🖊 Tips for Step 5

When depicting the open petals, apply colors from the outer edges toward the center, going from dark to light.

When depicting the curled petals, you can emphasize the shape of the petals by darkening the shadows around them.

6

a. ▥ 392 b. ▥ 380

Lastly, draw the flower center. Start by using burnt sienna to deepen the flower center. Then, use dark brown to further darken the small central hole and the shadows beneath the petals.

7

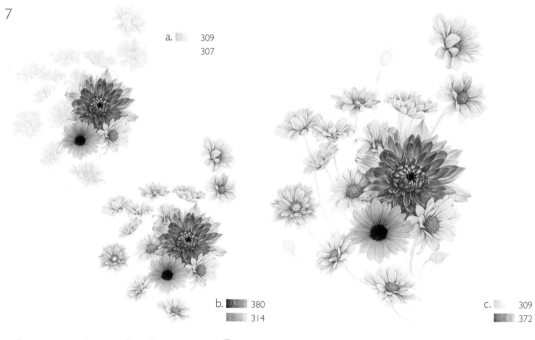

a. ▥ 309
 307

b. ▥ 380
 ▥ 314

c. ▥ 309
 ▥ 372

For the remaining clusters of small chrysanthemums, the drawing method is the same as before. Start by evenly applying a base coat of lemon yellow, using medium yellow to deepen the petals. Next, use yellowish orange to deepen the dark areas near the flower centers, depicting the texture of the petals. Draw the grain-like details in the flower centers, intensifying the darkest parts with dark brown. Finally, use olive green to deepen the grains in the darker area of the flower centers. Use medium yellow to apply base color to the stems and flower buds.

✏ **Tip for Step 7**

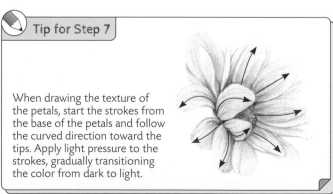

When drawing the texture of the petals, start the strokes from the base of the petals and follow the curved direction toward the tips. Apply light pressure to the strokes, gradually transitioning the color from dark to light.

8

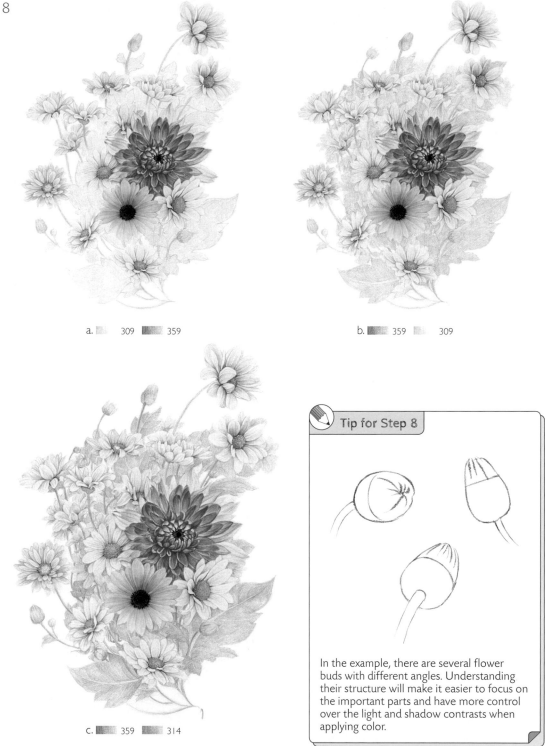

a. ▮ 309 ▮▮ 359

b. ▮▮ 359 ▮ 309

c. ▮▮ 359 ▮▮ 314

Tip for Step 8

In the example, there are several flower buds with different angles. Understanding their structure will make it easier to focus on the important parts and have more control over the light and shadow contrasts when applying color.

Use medium yellow to apply a base coat to the remaining leaves and deepen the color of the flower buds. Use emerald green to deepen the various receptacles and stems and lightly outline the edges of the leaves. Then, layer a shade of green over the leaves, making sure to leave partially obscured flowers, and deepen these flowers with medium yellow. Finally, further darken the leaves with emerald green and use yellowish orange to deepen the shadows of the remaining flowers and buds.

9

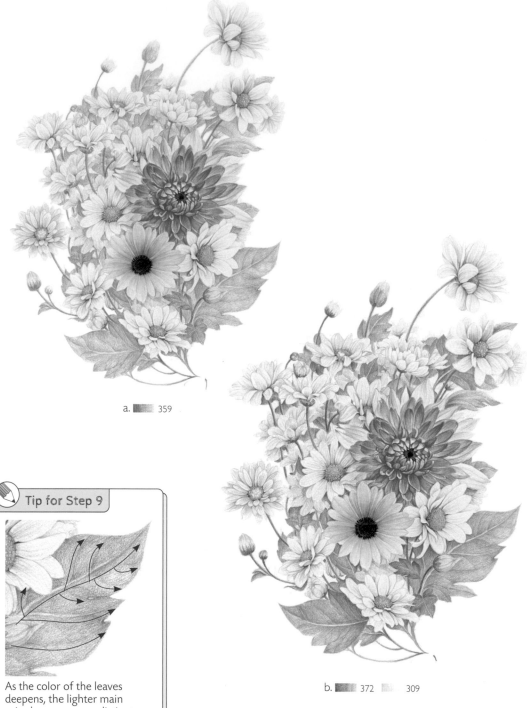

a. ▮▮ 359

Tip for Step 9

As the color of the leaves deepens, the lighter main veins become more distinct. It is important to note that veins are not solid lines but are represented by the contrast between the colors on both sides of the veins.

b. ▮▮ 372 ▮ 309

Continue using emerald green to deepen the shadowed areas of the leaves and leaf veins to depict the details. This will also help create separation and layering between the leaves. Finally, layer olive green over the leaves and continue to deepen the shadowed areas, especially the shadows beneath the flowers. Then, randomly layer medium yellow over the brighter areas of the leaves, adding richness to the color and creating a nostalgic warm tone for the leaves.

10

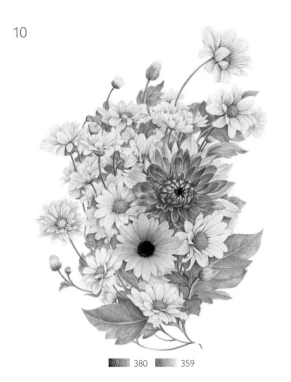

380 359

Using a combination of dark brown and emerald green, emphasize the shadowed areas of the leaves and the shadow beneath the flowers. Enhancing the contrast will help to create a sense of depth in the composition. Apply the colors lightly when layering, gently overlaying them in specific areas. Avoid excessive layering, as it can result in a muddy appearance.

Tip for Step 10

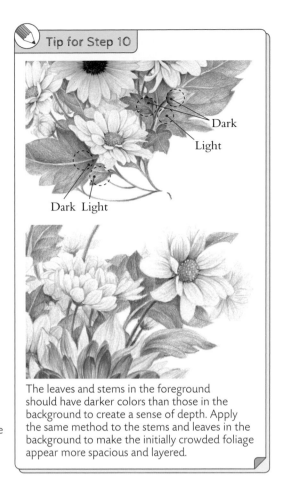

Dark
Light

Dark Light

The leaves and stems in the foreground should have darker colors than those in the background to create a sense of depth. Apply the same method to the stems and leaves in the background to make the initially crowded foliage appear more spacious and layered.

11

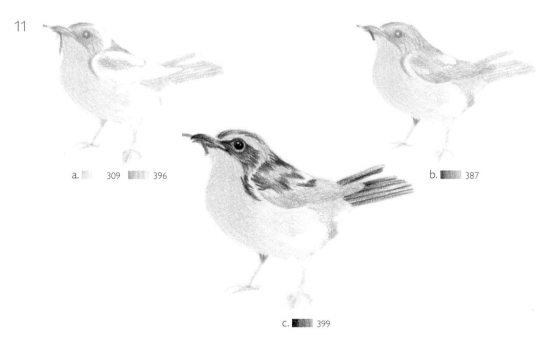

a. 309 396

b. 387

c. 399

First, apply a base color using medium yellow, gray, and yellowish brown to the different parts. Then, use black to darken certain areas of the hair. Draw the eye and leave the highlighted areas blank.

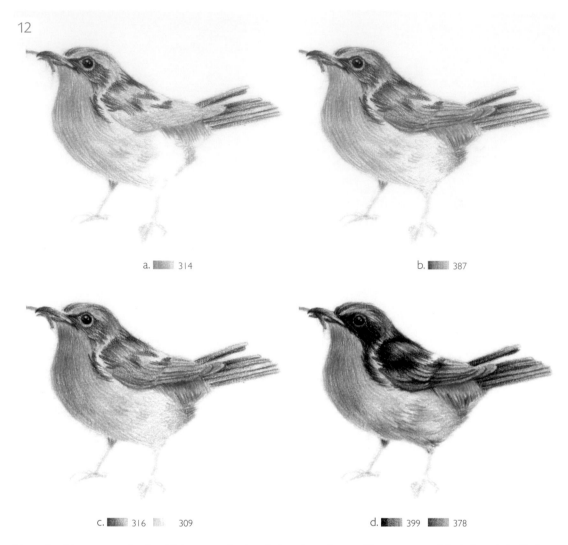

a. ▦ 314

b. ▦ 387

c. ▦ 316 ▦ 309

d. ▦ 399 ▦ 378

Use yellowish orange and yellowish brown to further darken the yellow and brown parts of the hair, and clarify the overlapping of the feathers on the wing. Then, use reddish orange to deepen the feathers on the chest and the tail feathers under the wing. Additionally, layering with medium yellow will enhance the saturation and create color transitions and variations in the feathers' hues. Finally, use black to deepen and refine the black feathers and use ocher to deepen the gaps between the wing feathers and the shadows beneath the wings.

✏️ **Tip for Step 12**

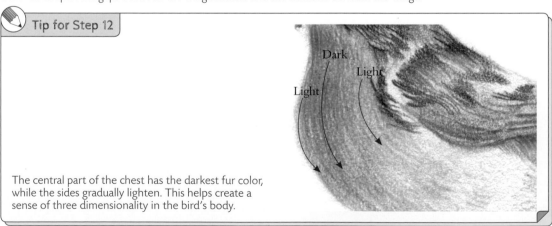

The central part of the chest has the darkest fur color, while the sides gradually lighten. This helps create a sense of three dimensionality in the bird's body.

13

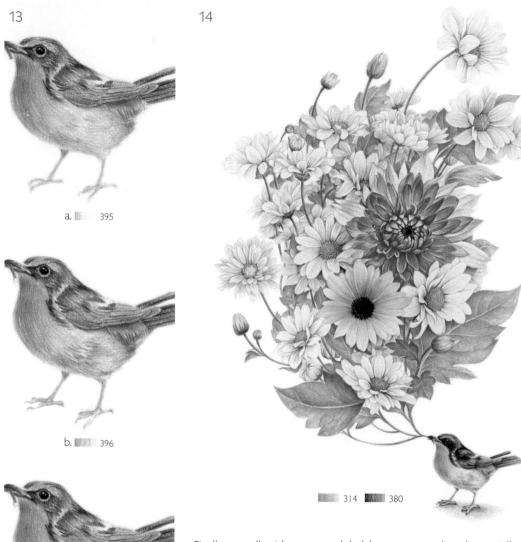

a. ▓▓ 395

b. ▓▓▓ 396

c. ▓▓▓ 399 ▓▓▓ 396

Draw the lower half of the abdomen with light gray and draw the feet, then darken the shadowed areas of the feathers with gray. Finally, draw the scales of the bird's claws in black, draw the shadow beneath the bird with gray, and further darken the shadow below the bird's claws with black.

14

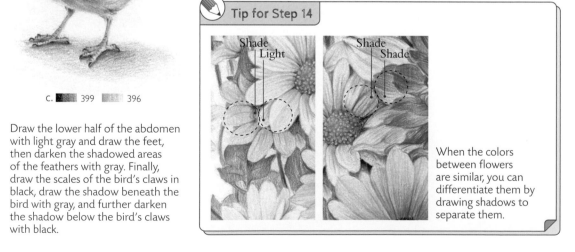

▓▓▓ 314 ▓▓▓ 380

Finally, use yellowish orange and dark brown to complete the partially obscured dark areas of the chrysanthemums and deepen the shadows between the flowers.

✏️ Tip for Step 14

Shade
Light

Shade
Shade

When the colors between flowers are similar, you can differentiate them by drawing shadows to separate them.

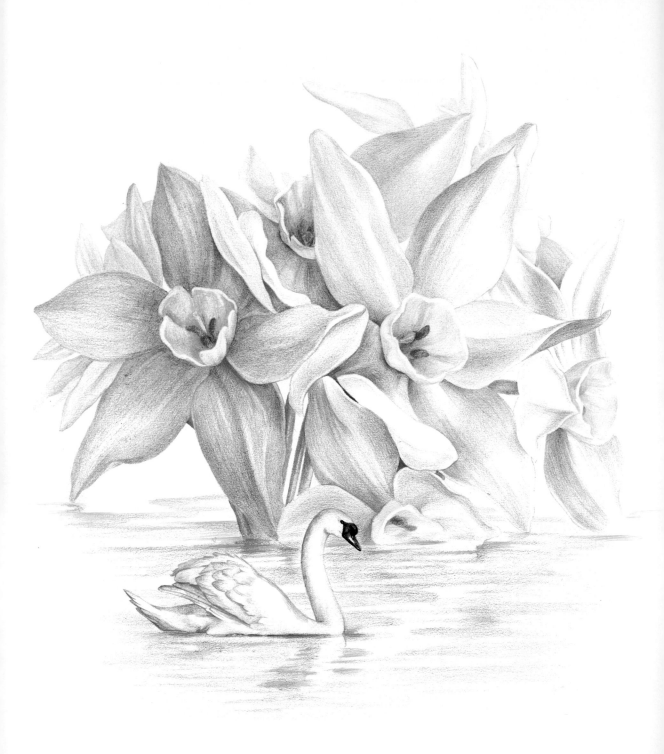

Swan and Narcissus

The narcissus has a cultivation history of over a thousand years in China. The Song dynasty poet Huang Tingjian (1045–1105) compared the narcissus to the goddess Luoshen, who walks on water under the moonlight, in his poetry. The narcissus is known for its delicate elegance and subtle fragrance. It blooms during the auspicious time of the Chinese New Year (on the first day of the lunar calendar), making it an important flower for the festive season. It represents the longing for and reunion with loved ones during the Spring Festival, and it symbolizes good fortune, beauty, and purity. The enchanting white flowers of the narcissus and the majestic elegance of the white swan are truly a perfect match. Swans typically inhabit clear waters, and their white feathers evoke a sense of purity and flawlessness. The presence of a swan often symbolizes the arrival of beauty and happiness.

In this piece, a gentle breeze brushes over the water surface, carrying the fragrance of the blooming narcissus. The swan gracefully revels in the tranquil, fragrant ambiance of the narcissus. The reflections of the narcissus and the swan gradually merge together as they extend with the ripples on the water.

Line Drawing

When sketching the outline, pay attention to the larger size of the flowers. Be mindful of the overlapping relationship between the petals, patiently drawing each petal and gently sketching the patterns on the petals.

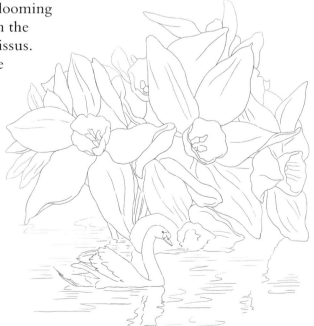

Colors Used

304 light yellow	307 lemon yellow	309 medium yellow
314 yellowish orange	318 scarlet red	335 pale purple
337 purple	341 dark purple	345 lake blue
343 ultramarine blue	344 Prussian blue	370 yellowish green
359 emerald green	357 blue green	363 dark green
372 olive green	396 gray	397 dark gray
399 black		

Composition

Add a subtle hue to the white narcissus blooms, giving them a slightly blue purple overall color tone. This will help enhance the sense of winter and create a harmonious contrast with the swan's delicate blue gray color. Exaggerate the proportions between the flowers and the bird. Create a dreamy effect by connecting the two different objects together through reflections and ripples on the water surface. Emphasize the larger narcissi and the swan outlined with dashed lines as the focal points for detailed depiction. The two main narcissus flowers should be the primary areas for applying color.

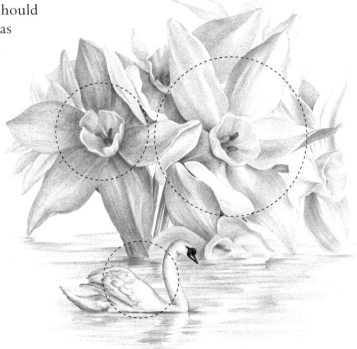

Steps

1

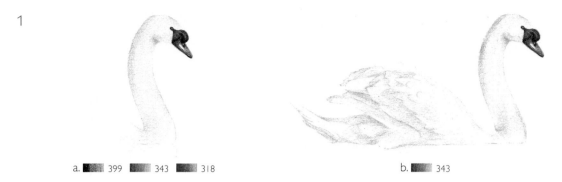

a. ▓ 399 ▓ 343 ▓ 318

b. ▓ 343

Start drawing from the head. Use black and scarlet red to depict the colors of the head, then gently apply ultramarine blue to the edges and darker areas of the feathers. Use the contrast between light and shadow to highlight the contours of the feathers.

2

a. ▓ 396

b. ▓ 397

Continuously use gray and dark gray to deepen the shadows between the feathers, using an even drawing technique. By intensifying the dark tones of the shadows, the white feathers will stand out. Pay attention to using the tip of the pencil to outline the shape of the feathers.

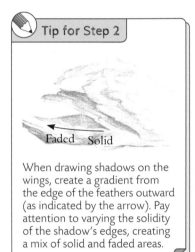

Tip for Step 2

Faded Solid

When drawing shadows on the wings, create a gradient from the edge of the feathers outward (as indicated by the arrow). Pay attention to varying the solidity of the shadow's edges, creating a mix of solid and faded areas.

3

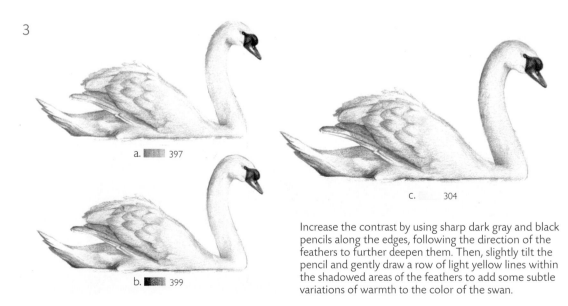

a. ▓ 397

b. ▓ 399

c. 304

Increase the contrast by using sharp dark gray and black pencils along the edges, following the direction of the feathers to further deepen them. Then, slightly tilt the pencil and gently draw a row of light yellow lines within the shadowed areas of the feathers to add some subtle variations of warmth to the color of the swan.

4

a. 307 ▬ 318 b. ▬ 309 ▬ 370 c. ▬ 370 ▬ 318
 ▬ 318 ▬ 314

Use lemon yellow to gently create a circular motion (the pencil moves gently in a circular motion while not leaving the paper) and apply a base color to the center of the flower. Apply scarlet red to the anther. Then, using the pencil tip, repeatedly layer and darken the base color and edges of the flower. Leave some lighter areas at the edges of the flower's center, and then apply shading to the bottom and darker edges of the flower center to depict the thickness of the flower's structure. Use a sharp pencil to deepen the contours and dark areas of the anther, as well as the inner parts and darker edge (highlighted with a red circle).

> **Tips for Step 4**
>
> Apply a gradient of color along the edges of the feathers to create a slight curvature to give the impression that the feathers on the wings are folding inward.
>
> Shade
>
> When depicting the light and shadow relationship of the flower's center, be careful to darken the bottom area of the flower to create a sense of indentation.

5

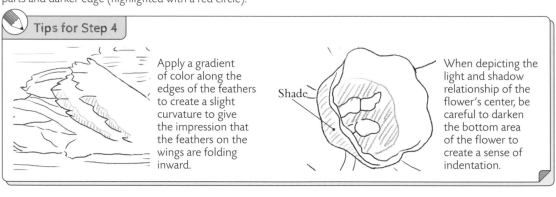

a. ▬ 345 b. ▬ 343 c. ▬ 341

Draw the petals. Start by using lake blue to follow the main veins of the petals, emphasizing their inherent color. Then use ultramarine blue to deepen the shadows of the petals and gradually draw their texture. Finally, overlay dark purple on the dark areas of the petals and deepen the texture of the shadows.

6

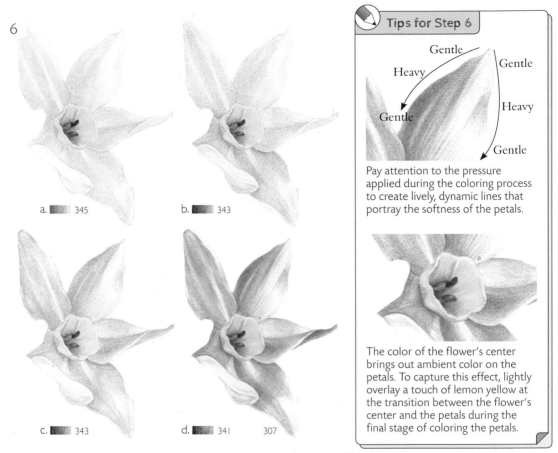

a. ▮▮ 345

b. ▮▮▮ 343

c. ▮▮▮ 343

d. ▮▮▮ 341 307

Tips for Step 6

Gentle

Heavy

Gentle

Gentle

Heavy

Gentle

Pay attention to the pressure applied during the coloring process to create lively, dynamic lines that portray the softness of the petals.

The color of the flower's center brings out ambient color on the petals. To capture this effect, lightly overlay a touch of lemon yellow at the transition between the flower's center and the petals during the final stage of coloring the petals.

Repeat the same method to draw the remaining petals. Layer the colors of lake blue, ultramarine blue, and dark purple on the petals in turn. Pay attention to the variations in the solidity of the petal edges and gently deepen the areas where the petals overlap. Gently overlay a touch of lemon yellow in the dark areas near the flower's center to create the ambient color of the petals.

7

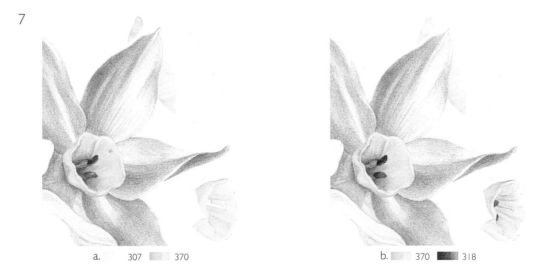

a. 307 ▮▮ 370

b. ▮▮ 370 ▮▮▮ 318

Use the same method to draw the rear flower centers. Start by using lemon yellow and yellowish green to depict the flower centers, and lightly apply scarlet red for the color of the anthers. The color of the rear flower centers should be lighter to avoid overshadowing the main focus.

8

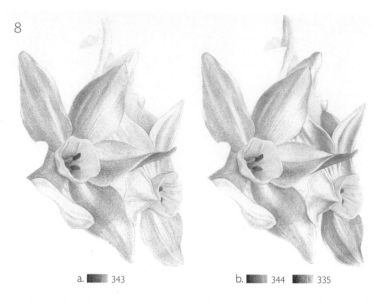

a. ▮▮ 343 b. ▮▮ 344 ▮▮ 335

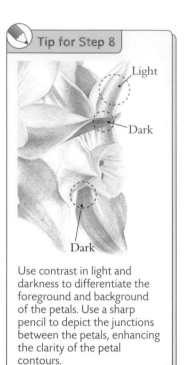

Tip for Step 8

Light

Dark

Dark

Use contrast in light and darkness to differentiate the foreground and background of the petals. Use a sharp pencil to depict the junctions between the petals, enhancing the clarity of the petal contours.

Use ultramarine blue to gently create a gradient along the texture of the petals, starting from the edges and fading toward the inner part of the petals. Use Prussian blue to darken the bottom of the petals and the areas where they overlap. Add a touch of pale purple in the shadows to introduce some color variation to the petals.

9

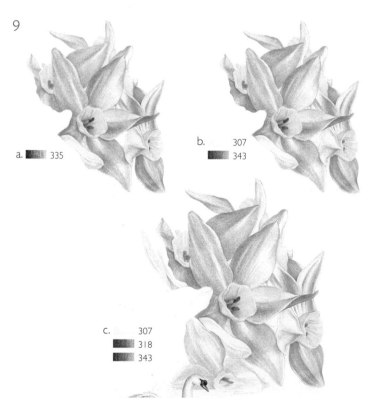

a. ▮▮ 335 b. 307
▮▮ 343

c. 307
▮▮ 318
▮▮ 343

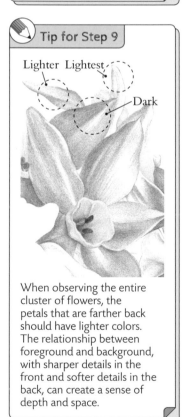

Tip for Step 9

Lighter Lightest

Dark

When observing the entire cluster of flowers, the petals that are farther back should have lighter colors. The relationship between foreground and background, with sharper details in the front and softer details in the back, can create a sense of depth and space.

For the petals on the left side toward the back, start by applying a base color of pale purple, with slightly heavier lines for the central pattern. Then, use ultramarine blue to deepen the bottom of the petals, and gently overlay a touch of lemon yellow near the flower's center. The flowers closer to the water surface can also be drawn using lemon yellow and scarlet red for the flower center and ultramarine blue for the petals. Lightly darken the edges of the petals.

10

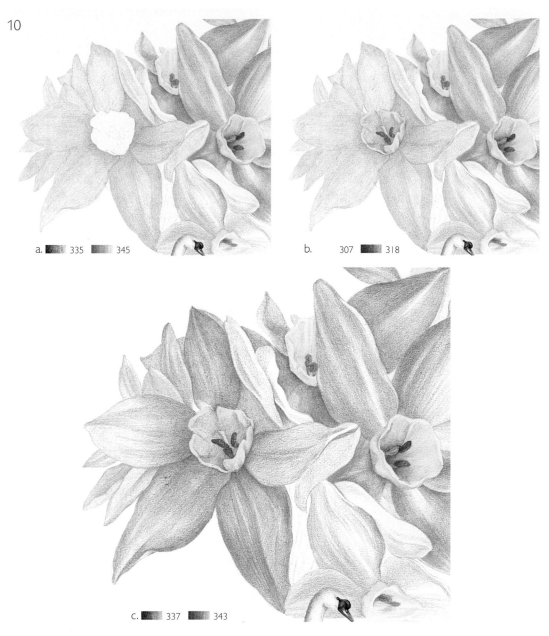

a. ▮▮ 335 ▮▮ 345

b. 307 ▮▮ 318

c. ▮▮ 337 ▮▮ 343

The flower on the far left is in the darker area of the entire bouquet. Start by evenly applying a layer of pale purple to the petals, then use lemon yellow and scarlet red to draw the flower center. Use pale purple and ultramarine blue to deepen the petals, applying slightly more pressure on the edges and along the petal's texture to distinguish the outline of the petals.

Tip for Step 10

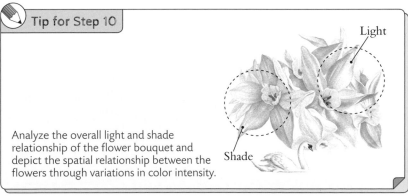

Light

Shade

Analyze the overall light and shade relationship of the flower bouquet and depict the spatial relationship between the flowers through variations in color intensity.

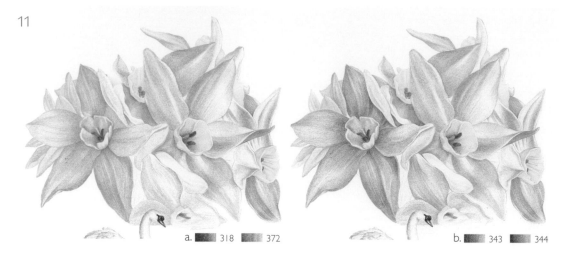

a. ▮ 318 ▮ 372 b. ▮ 343 ▮ 344

Deepen the center of the flower with a combination of scarlet red and olive green, and depict its thickness by leaving some areas brighter along the edges. Overlay the flower petals with a layer of ultramarine blue to create a connection between the petals and the brighter flowers on the right, enhancing the overall cohesion. Use Prussian blue to darken the petals near the center of the flower. Finally, use Prussian blue to darken along the edges of the petals, applying slightly more pressure at the tips of the petals to emphasis.

12

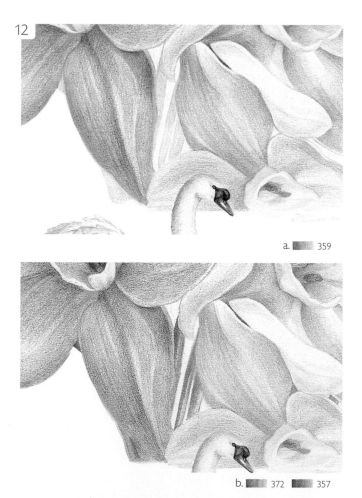

a. ▮ 359

b. ▮ 372 ▮ 357

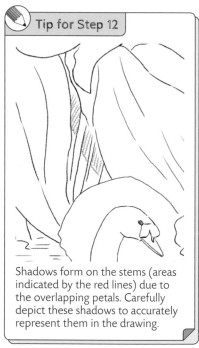

Tip for Step 12

Shadows form on the stems (areas indicated by the red lines) due to the overlapping petals. Carefully depict these shadows to accurately represent them in the drawing.

To depict the hidden stems behind the flowers, start by evenly applying a layer of emerald green, followed by blue green to darken the shadowed areas of the stems. Apply a darker layer of color near the flowers to create overall depth. Use olive green to depict the shadows cast by the petals on the stems.

13

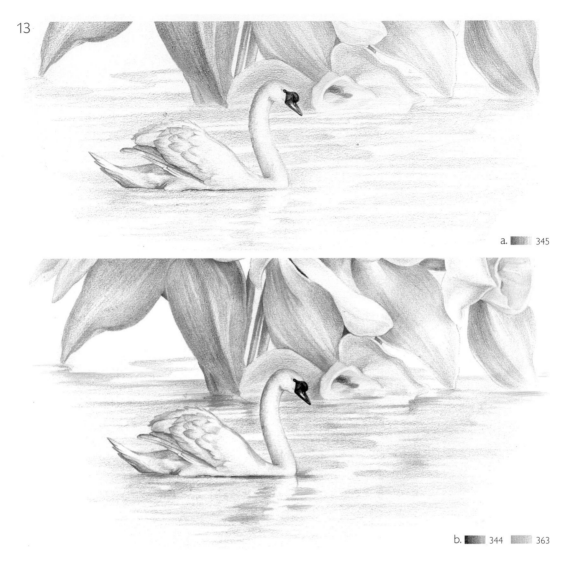

a. ▮▮ 345

b. ▮▮ 344 ▭▭ 363

Using lake blue, draw the color of the water ripples. Apply slightly more pressure near the flowers and the swan to create a darker shade. Use Prussian blue to deepen the color of the water ripples, emphasizing the reflection of the swan in the water. Then, layer a dark green shade near the stems to depict their reflection.

✎ **Tips for Step 13**

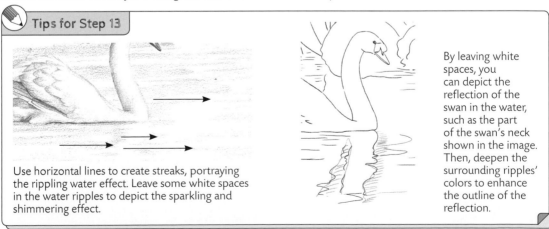

Use horizontal lines to create streaks, portraying the rippling water effect. Leave some white spaces in the water ripples to depict the sparkling and shimmering effect.

By leaving white spaces, you can depict the reflection of the swan in the water, such as the part of the swan's neck shown in the image. Then, deepen the surrounding ripples' colors to enhance the outline of the reflection.

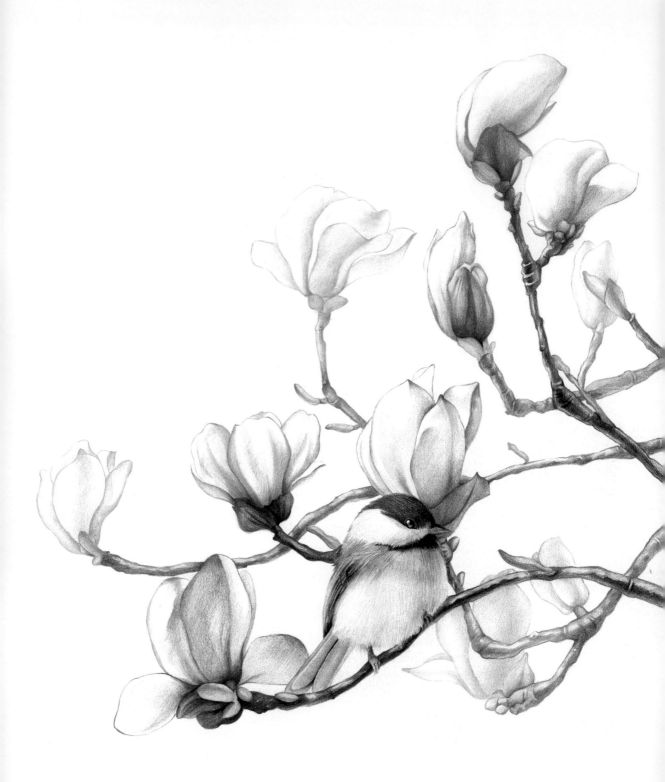

Marsh Tit and Magnolia

The magnolia shares its name with the legendary Chinese heroine, Hua Mulan, who disguised herself as a man to join the army in place of her father. This flower not only possesses elegance and beauty but, like Hua Mulan, also embodies a pure, noble soul. The blooming period of the magnolia is from February to March. While other plants are still budding and sprouting new branches, the magnolia blossoms early, adorning the tree with abundant flowers to welcome the arrival of spring. Throughout history, countless people have praised the magnolia flower. Its unique characteristic of blooming before growing leaves has garnered much appreciation. During its peak bloom, the tree is often devoid of leaves, showcasing a pure white color. The pristine, sacred beauty of the magnolia instills a sense of reverence and admiration. The marsh tit is small and adorable, with a soft, delicate call. Its black, white, and gray feathers are simple and elegant, resembling a beautiful ink drawing.

In this piece, the faint magnolia flowers exude a sense of winter chill. A marsh tit perches on a branch, adding a touch of vitality to the desolate winter day.

Line Drawing

Outline the sketch, paying attention to the intricate branches. Start by determining the direction of the branches, and then position the flowers accordingly. This approach will make it easier to capture their shapes accurately.

Colors Used

309 medium yellow	387 yellowish brown	378 ocher
392 burnt sienna	376 brown	380 dark brown
319 pink	335 pale purple	341 dark purple
347 sky blue	343 ultramarine blue	344 Prussian blue
370 yellowish green	372 olive green	397 dark gray
399 black		

Composition

In the composition, there are several upward-curving branches that traverse the scene. We choose the larger magnolia flower in the foreground and the bird to form the main focal point of the composition. The flowers are arranged in different sizes and positioned in the foreground and background, creating a sense of depth in the composition. The bird and magnolia flowers enclosed within the dotted lines are the focal points of the piece.

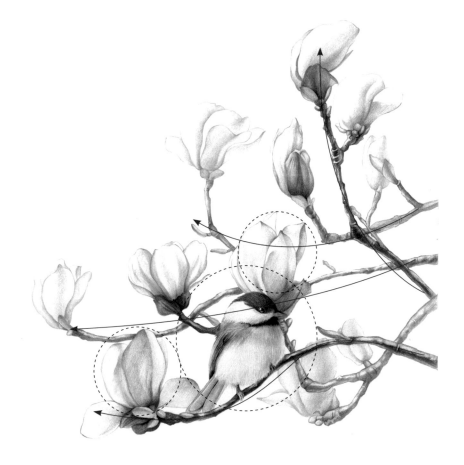

Steps

1

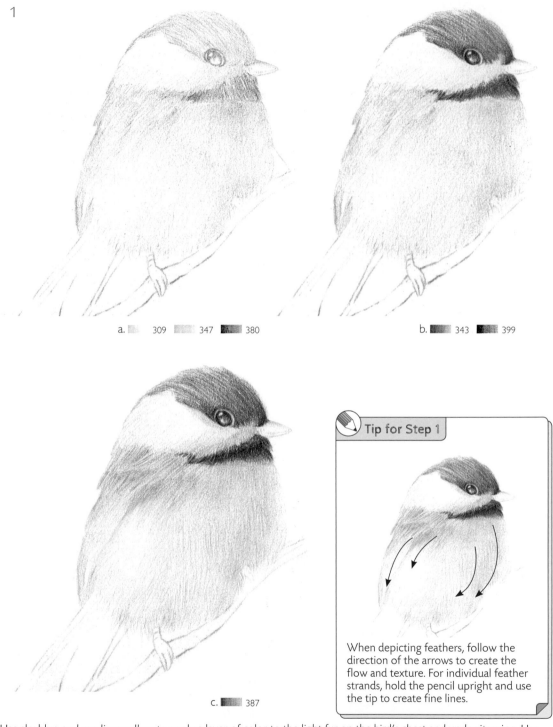

a. ▨ 309　▨ 347　▨ 380　　　　　b. ▨ 343　▨ 399

c. ▨ 387

Tip for Step 1

When depicting feathers, follow the direction of the arrows to create the flow and texture. For individual feather strands, hold the pencil upright and use the tip to create fine lines.

Use sky blue and medium yellow to apply a layer of color to the light fur on the bird's chest and under its wing. Use dark brown to gently depict the color of the feathers on its head and neck. Use ultramarine blue to deepen the shadows and create the transition between the chest and the bird's face. This will help establish the overall light and shadow relationship. Use black to darken the feathers on the head and in front of the neck. Then, gently deepen the color of the feathers behind the neck using yellowish brown.

a. ▬ 397 ▬ 399 ▬ 376

b. ▬ 399

c. ▬ 397 ▬ 376

d. ▬ 399

Use dark gray to deepen the color of the wing. Use black to darken the gaps between the wing feathers. Use brown to deepen the feathers at the back of the neck, creating a denser appearance. Gradually layer the tail with dark gray and black, paying attention to leaving some bright areas along the edges. After applying the base color to the feet of the marsh tit in dark gray, add a touch of brown in the darker areas. With black, lightly layer the feet in the areas near the body to create a sense of shadow. Finally, use the tip of the pencil to gently draw the darker lines horizontally across the feet, including the patterns and gaps between the toes.

Tip for Step 2

Shadowed area

The tail should have a slight protruding effect. When drawing, lightly darken the shadowed area.

3

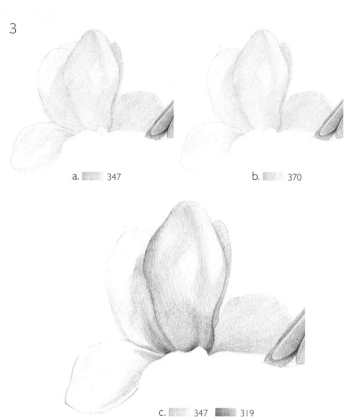

a. ▓▒░ 347

b. ▓▒░ 370

c. ▓▒░ 347 ▓▓▒ 319

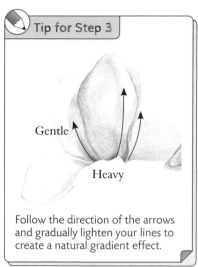

Tip for Step 3

Gentle

Heavy

Follow the direction of the arrows and gradually lighten your lines to create a natural gradient effect.

Start with the bottom flower and lightly apply a layer of sky blue, leaving the highlights of the petals untouched. Add a touch of yellowish green in the shadowed areas. Next, deepen the shadowed areas with sky blue to make the contours of the petals clearer. Then, gently add a touch of pink near the bottom of the petals to depict the color variation of the magnolia.

4

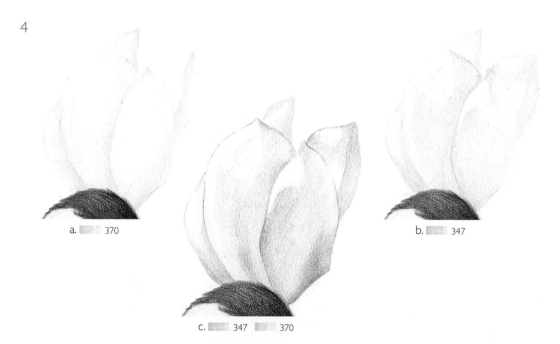

a. ▓▒░ 370

b. ▓▒░ 347

c. ▓▒░ 347 ▓▒░ 370

Color the flower on the bird's head. Begin from the edges of the shadowed areas and gradually apply a gradient of yellowish green to distinguish the contours of the petals. Next, lightly apply sky blue over the entire dark area to create a harmonious connection with the previously drawn flower. Likewise add a touch of pink at the bottom of the petals.

5

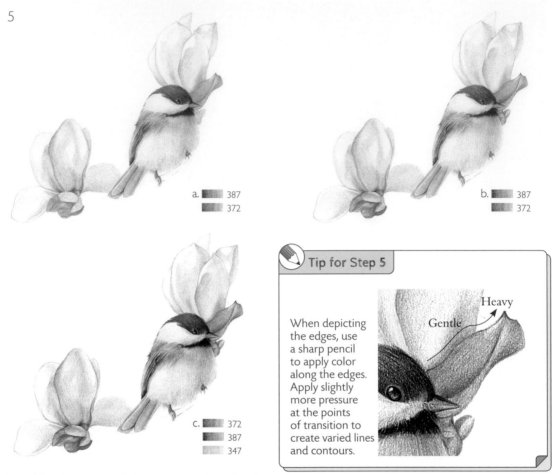

a. ▮▮▮ 387
▮▮ 372

b. ▮ 387
▮▮ 372

c. ▮ 372
▮▮ 387
▮▮ 347

Tip for Step 5

When depicting the edges, use a sharp pencil to apply color along the edges. Apply slightly more pressure at the points of transition to create varied lines and contours.

Gentle Heavy

Using yellowish brown and olive green, gently apply color to depict the calyxes and the tender green sepals on them. Use yellowish brown to darken the edges of the calyxes and to create shadows where the green sepals overlap the calyxes. Next, gently deepen the shadows of the green sepals using a sharp olive-green pencil. Use sky blue to adjust the color of the petals, applying a color gradient from the edges inward to enhance the clarity of the petal contours.

6

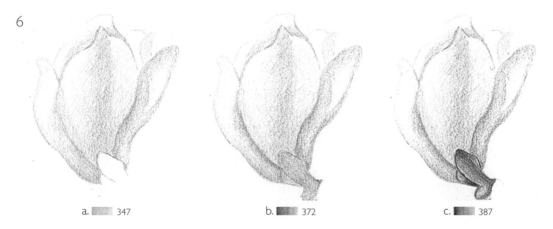

a. ▮ 347

b. ▮ 372

c. ▮ 387

The petals of the leftmost flower are directly colored with sky blue, and the gradient color is applied from the edge to the inside of the petals. The contrast line between light and dark is deepened in the middle of the petal, and an additional layer of color is added to the bottom of the petals as a whole. The calyx is colored with olive green and yellowish brown in turn.

7

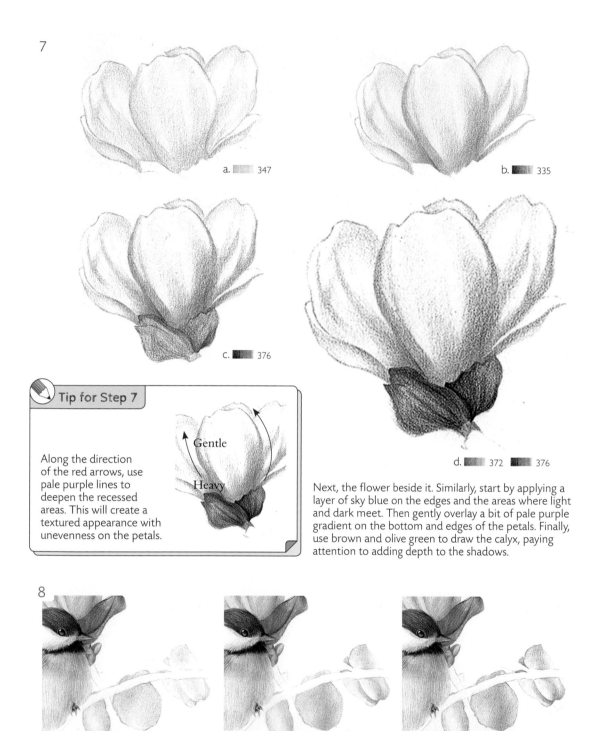

a. ▮ 347

b. ▮ 335

c. ▮ 376

d. ▮ 372 ▮ 376

Tip for Step 7

Along the direction of the red arrows, use pale purple lines to deepen the recessed areas. This will create a textured appearance with unevenness on the petals.

Gentle

Heavy

Next, the flower beside it. Similarly, start by applying a layer of sky blue on the edges and the areas where light and dark meet. Then gently overlay a bit of pale purple gradient on the bottom and edges of the petals. Finally, use brown and olive green to draw the calyx, paying attention to adding depth to the shadows.

8

a. ▮ 347

b. ▮ 335

c. ▮ 372

Deal with the flowers below the bird. Apply sky blue, pale purple, and olive green to the flowers in the background in sequence. Pay attention to using lighter strokes, allowing this group of flowers to have a lighter color tone and weaker contrast. This will create a contrast with the larger flowers in the foreground in terms of solidity and emptiness.

9

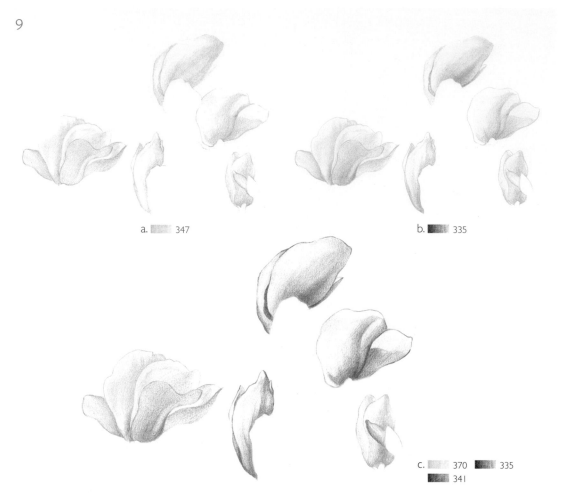

a. ▪▪▪ 347

b. ▪▪▪ 335

c. ▪▪▪ 370 ▪▪▪ 335
▪▪▪ 341

Color the flowers above the scene. Use sky blue, pale purple, and dark purple in sequence. Finally, gently overlay a touch of yellowish green on the brighter areas to enrich the color of the petals. When depicting the edges of the petals, there should be variations in the intensity of the lines. You can apply slightly heavier pressure on the pencil at the points where the petals bend.

10

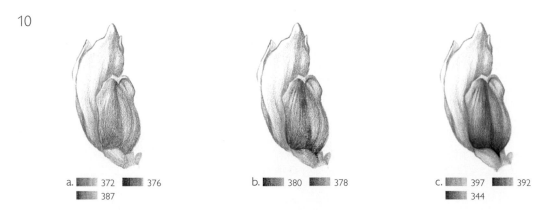

a. ▪▪▪ 372 ▪▪▪ 376
▪▪▪ 387

b. ▪▪▪ 380 ▪▪▪ 378

c. ▪▪▪ 397 ▪▪▪ 392
▪▪▪ 344

The calyxes are colored with yellowish brown, brown, ocher, and dark brown. Pay attention to depicting the texture of the sepal folds, deepen the bottom of the calyxes to portray their three-dimensional appearance. The young shoots are represented with olive green. Finally, use dark gray, burnt sienna and Prussian blue to further enhance the depth and create the ambient color.

11

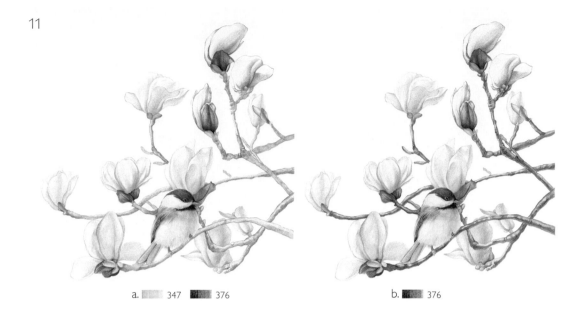

a. ▭ 347 ▬ 376

b. ▬ 376

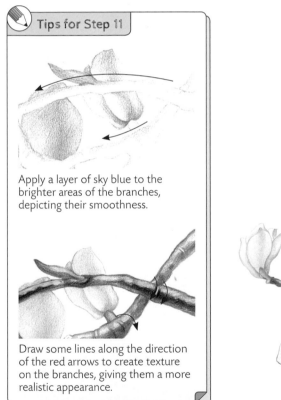

Tips for Step 11

Apply a layer of sky blue to the brighter areas of the branches, depicting their smoothness.

Draw some lines along the direction of the red arrows to create texture on the branches, giving them a more realistic appearance.

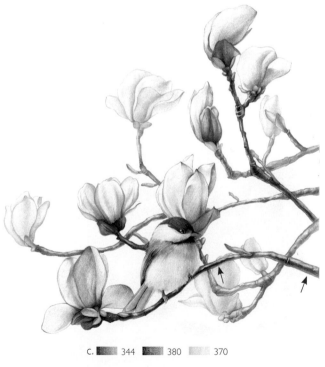

c. ▬ 344 ▬ 380 ▭ 370

Finally, draw the branches. Start by gently applying a layer of sky blue to the brighter areas. Then use brown to depict the base color of the branches in the darker areas. Deepen the contrast between light and dark at the junction of the branches, leaving a reflection at the lower end of the dark portion of the branches (as indicated by the arrows). Draw some horizontal lines to represent the texture of the branches. Finally, use a touch of Prussian blue and yellowish green to adjust the color of the foreground flowers, creating a greater contrast between them and those in the background in terms of solidity and emptiness. Use dark brown to deepen the branches in the foreground, enhancing the overall sense of depth in the composition.

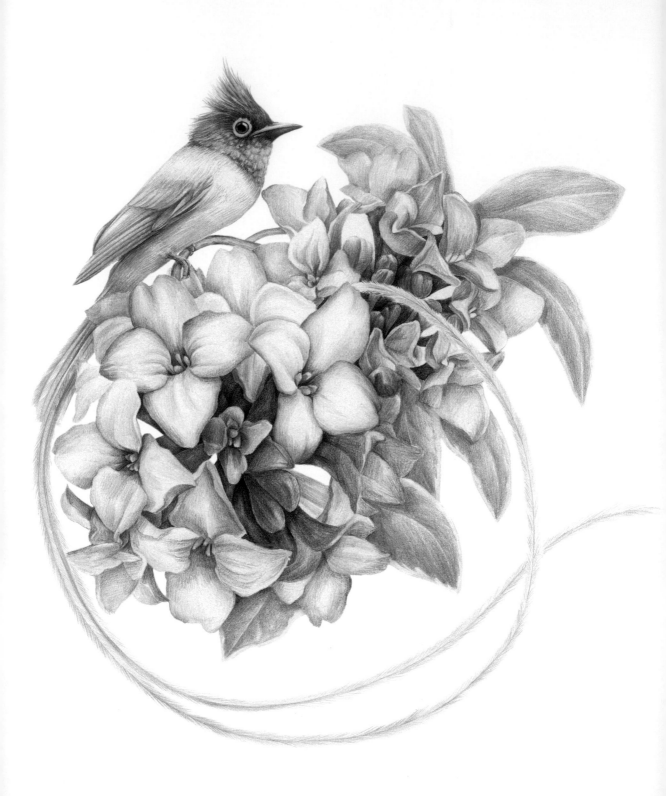

Amur Paradise Flycatcher and Daphne Odora

Daphne odora is a traditional flower in China, blooming during the auspicious time of the Chinese New Year. Its flowers fill the branches with a delightful fragrance, forming clusters and adding a festive touch. It symbolizes good luck and represents wishes for a smooth and prosperous life. The amur paradise flycatcher and the daphne odora sing together, bringing an auspicious omen to the winter and spring season. The flycatcher is distinguished by its two long tail feathers that resemble ribbons. Due to its name being homophonous with the word longevity (*shou*) in Chinese, it is considered a symbol of longevity and good fortune.

In this piece, a cluster of daphne odora blooms vibrantly, with its large and dense flowers seemingly able to pierce the paper. The small, adorable amur paradise flycatcher delicately perches on the flower branches, its long tail feathers encircling the blossoms, as if savoring the rich beauty all to itself.

Line Drawing

The overall composition is circular. The flowers of the daphne odora are depicted using smooth, flowing lines. The feathers of the amur paradise flycatcher can be represented using a combination of fine, fragmented short lines and smooth, long lines.

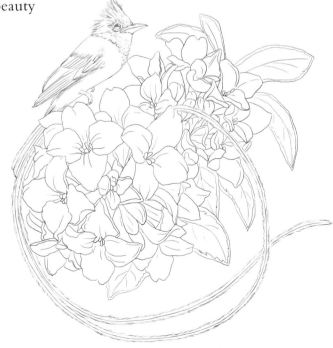

Colors Used

307 lemon yellow	309 medium yellow	314 yellowish orange
383 earth yellow	316 reddish orange	330 salmon
329 peach red	325 rose red	327 eosin
321 bright red	335 pale purple	337 purple
341 dark purple	344 Prussian blue	347 sky blue
354 light blue	351 dark blue	353 navy blue
343 ultramarine blue	366 grass green	361 phthalo green
357 blue green	372 olive green	399 black

Composition

The overall color scheme of the composition consists of shades of blue purple and purple red. The purple red flowers of the daphne odora are paired with the blue purple amur paradise flycatcher, creating a fusion of the auspiciousness of the New Year and the coldness of winter through color. The tail feathers of the amur paradise flycatcher can be exaggeratedly elongated, wrapping them around the clustered golden edged daphne odora blooms to create a circular composition, making the piece full and decorative. The dashed lines indicate the focal points of the composition, highlighting the parts that need to be depicted and emphasized with careful attention to detail.

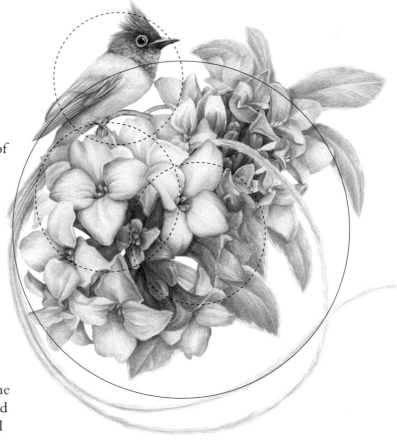

Steps

1

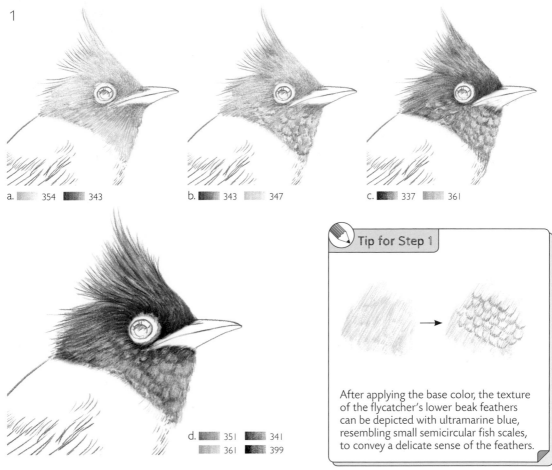

a. ▥ 354 ▰ 343

b. ▰ 343 ▨ 347

c. ▰ 337 ▨ 361

d. ▰ 351 ▰ 341
 ▥ 361 ▰ 399

Tip for Step 1

After applying the base color, the texture of the flycatcher's lower beak feathers can be depicted with ultramarine blue, resembling small semicircular fish scales, to convey a delicate sense of the feathers.

First, use light blue to fill in the base color along the direction of feather growth on the head. Then, use ultramarine blue to deepen the area around the eye and beak. Next, draw the scaled feathers on the neck and layer them with sky blue on top. Use purple to deepen the feathers around the beak and eye. Use dark purple and dark blue to depict the dark areas around the eye and the shadows between the tufts of raised crest feathers. Overlay phthalo green on the throat to enrich the color variation. Use black to strengthen the edges around the beak.

2

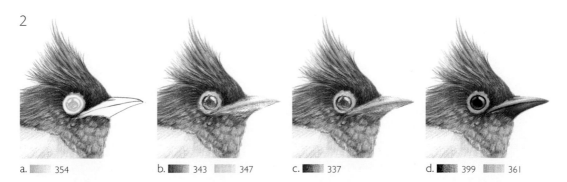

a. ▥ 354

b. ▰ 343 ▨ 347

c. ▰ 337

d. ▰ 399 ▨ 361

Gently apply light blue as a base color to the eye, leaving highlights and eye socket. Then lightly deepen the pupil with ultramarine blue, and the eye socket and beak with sky blue, leaving the highlight above the beak. Overlay some purple below the beak, and then use black to deepen the dark areas of the eye and the beak. Finally, gently transition a bit of phthalo green in the highlights.

3

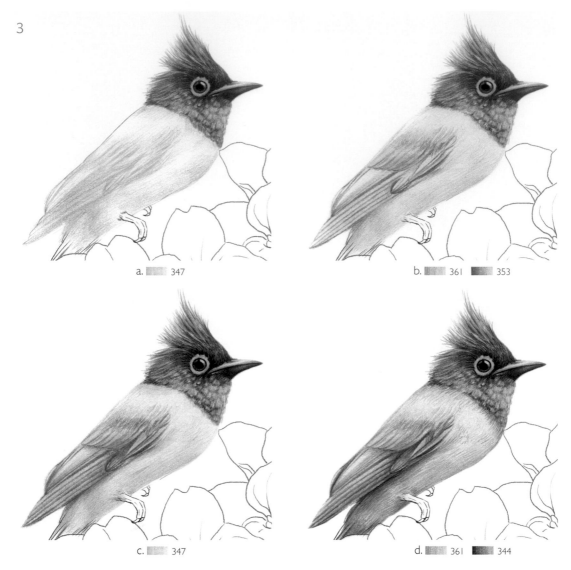

a. ▨▨ 347

b. ▨▨ 361 ▨▨ 353

c. ▨▨ 347

d. ▨▨ 361 ▨▨ 344

Draw the body and wings of the flycatcher. Start by lightly applying sky blue to the body and wings, deepening the wing structure to establish a rough light and shadow relationship. Overlay a small amount of phthalo green onto the chest and abdomen to enhance the hue. Use navy blue to deepen the edges where the wing feathers overlap. With a sharp sky-blue pencil, further deepen the dark areas of the wings and body. Overlay phthalo green onto the lower part of the abdomen under the wings, and use Prussian blue to further enhance the edges of the dark areas.

4

a. ▨▨ 347

b. ▨▨ 335

c. ▨▨ 341 ▨▨ 329

Differentiate the light and dark areas of the claws using sky blue. Then overlay the overall color with pale purple. Use dark purple to depict the dark details of the claws. Finally, apply a touch of peach red to adjust the color tone.

5

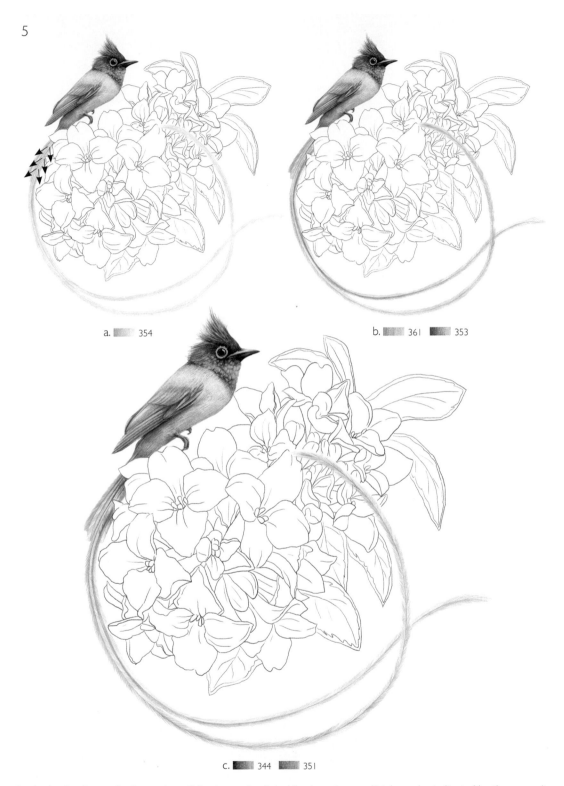

a. ▭ 354

b. ▭ 361 ▬ 353

c. ▬ 344 ▬ 351

Apply the first layer of color to the tail feathers using light blue in an inverted V shape (as indicated by the arrows). Then, use short strokes in phthalo green and navy blue to deepen the colors of the tail feathers. Sharpen a Prussian blue pencil and focus on darkening the shadowed areas between the tail feathers. Then, selectively draw some clear fine lines with dark blue on the feathers to enhance the sense of detail.

6

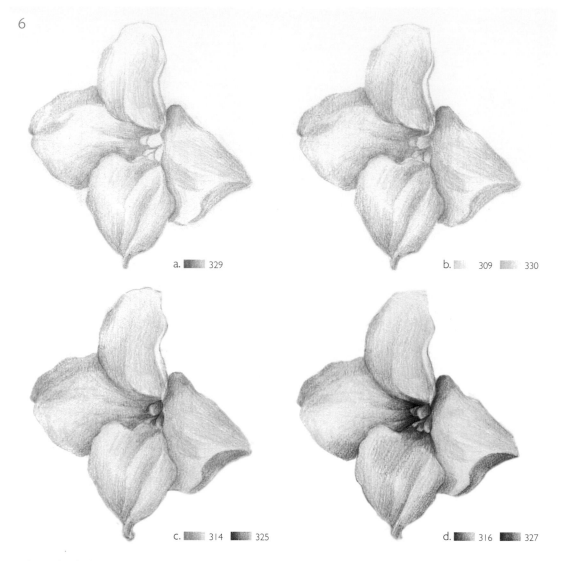

a. ▮▮▮ 329

b. ▮▮ 309 ▮▮ 330

c. ▮▮ 314 ▮▮ 325

d. ▮▮ 316 ▮▮ 327

To depict the daphne odora flowers, control the pressure of your lines as you lightly apply a gradient base color using peach red. Layering salmon can make the petals appear more delicate and rosier. Use medium yellow to the base color of the stamen, and then add a touch of the same yellow shade in the center of the petals. Next, use rose red and yellowish orange to deepen the color of the petals and the stamen. Finally, use reddish orange and eosin to deepen the color of the flower's core and the shadows between the petals.

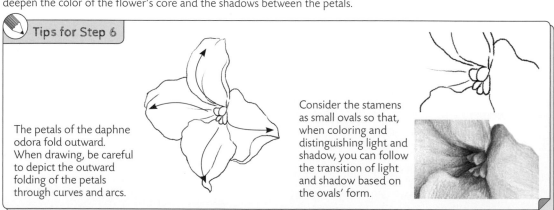

Tips for Step 6

The petals of the daphne odora fold outward. When drawing, be careful to depict the outward folding of the petals through curves and arcs.

Consider the stamens as small ovals so that, when coloring and distinguishing light and shadow, you can follow the transition of light and shadow based on the ovals' form.

7

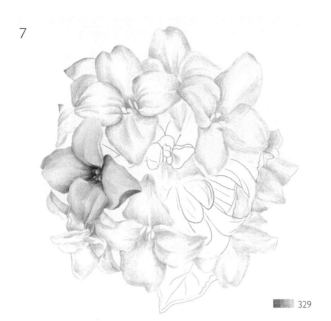

329

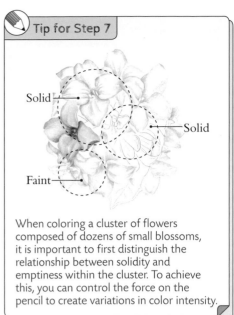

With a sharp peach red pencil, gently apply the color along the edges of the petals, gradually moving inward. When drawing, vary the pressure from heavy to light so that the color gradient of the petals will appear natural and the contours of the petals will be clearer.

8

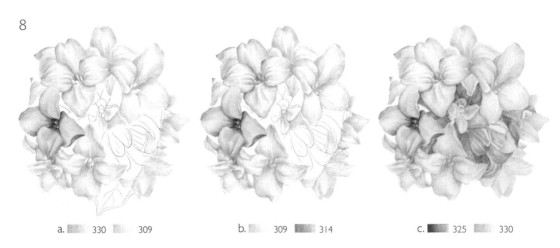

a. 330 309 b. 309 314 c. 325 330

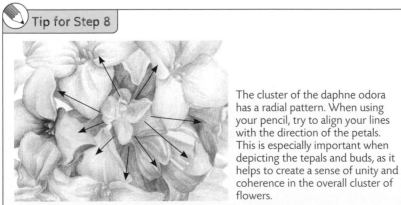

Use a light layer of salmon and medium yellow to gently overlap the colors. Then, use medium yellow and yellowish orange to paint the base color and dark areas of the stamens. Then, use rose red to depict the darker petals that are partially hidden. Apply salmon to the lighter areas of the petals. When layering the colors, use different shades to differentiate the layers of the petals.

9

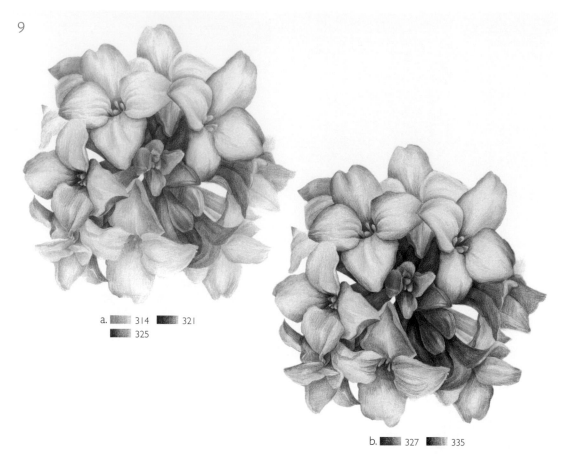

a. ▮ 314 ▮ 321
▮ 325

b. ▮ 327 ▮ 335

Layer yellowish orange over the petals, and then use a combination of bright red and rose red to darken the overall color of the tepals. When applying the lines, aim for evenness and consistency. Finally, with sharp eosin and pale purple pencils, focus on intensifying the edges of the darker areas to make the contrast between light and shadow more pronounced in the flower cluster.

10

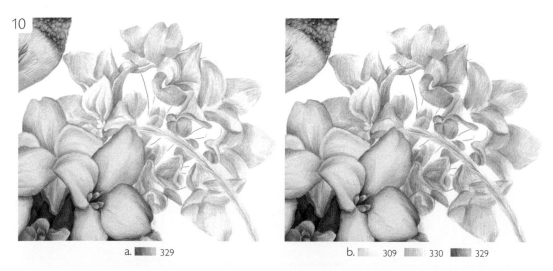

a. ▮ 329

b. ▮ 309 ▮ 330 ▮ 329

Use a light touch to apply a base color of peach red to the remaining flowers. Then, layer medium yellow on the flower centers and some of the central parts of the petals. Apply salmon over the petals and use peach red to darken their edges, making the relationships between the petals more defined.

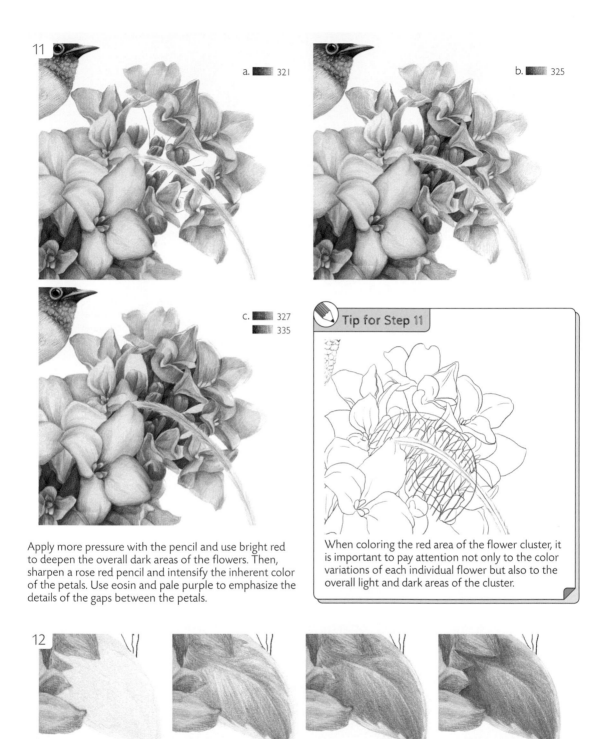

11

a. ▮▮ 321

b. ▮▮ 325

c. ▮▮ 327
▮▮ 335

Tip for Step 11

When coloring the red area of the flower cluster, it is important to pay attention not only to the color variations of each individual flower but also to the overall light and dark areas of the cluster.

Apply more pressure with the pencil and use bright red to deepen the overall dark areas of the flowers. Then, sharpen a rose red pencil and intensify the inherent color of the petals. Use eosin and pale purple to emphasize the details of the gaps between the petals.

12

a. ▮ 307

b. ▮▮ 357

c. ▮▮ 366 ▮▮ 353
▮▮ 383

d. ▮▮ 357 ▮▮ 372

Use lemon yellow to draw the base color and blue green for the color of the leaves, following the direction of the leaf veins. Leave a border of "gold" along the edges of the leaves. Use navy blue, earth yellow, and grass green to layer along the edges and in the shaded areas of the leaves. Use blue green and olive green to deepen the shadows of the petals on the leaves.

13

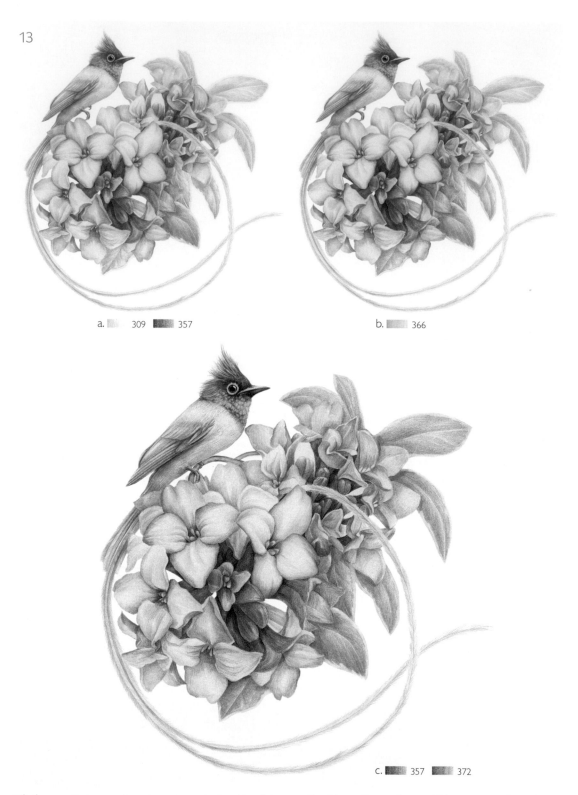

a. ▨ 309 ▨ 357

b. ▨ 366

c. ▨ 357 ▨ 372

Tilt the pencil at an angle and gently apply the side of the pencils with medium yellow and blue green to draw the other leaves. Use grass green to gently deepen the leaves, establishing the light and shadow relationship of the leaves. Finally, use a combination of blue green and olive green to layer and depict the shadows of the leaves, as well as the shadows cast by the flowers onto the leaves.

Tear-Out Templates

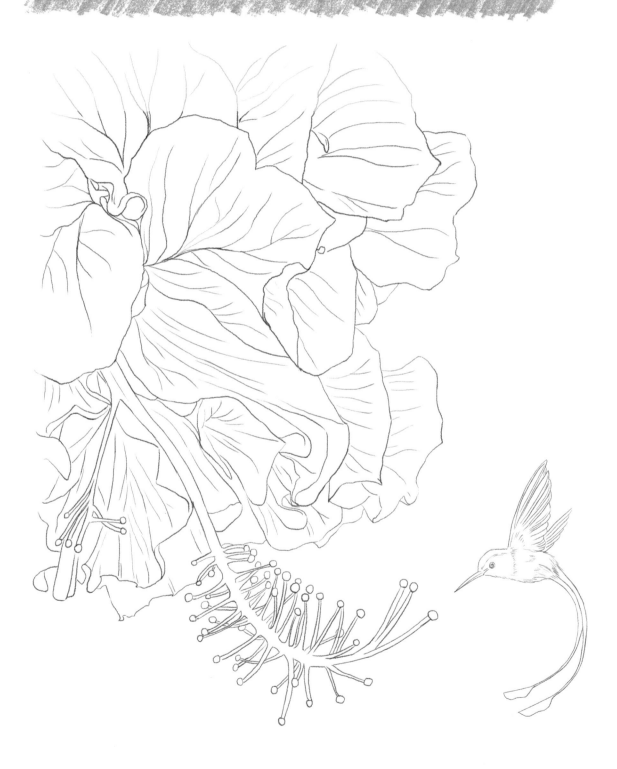

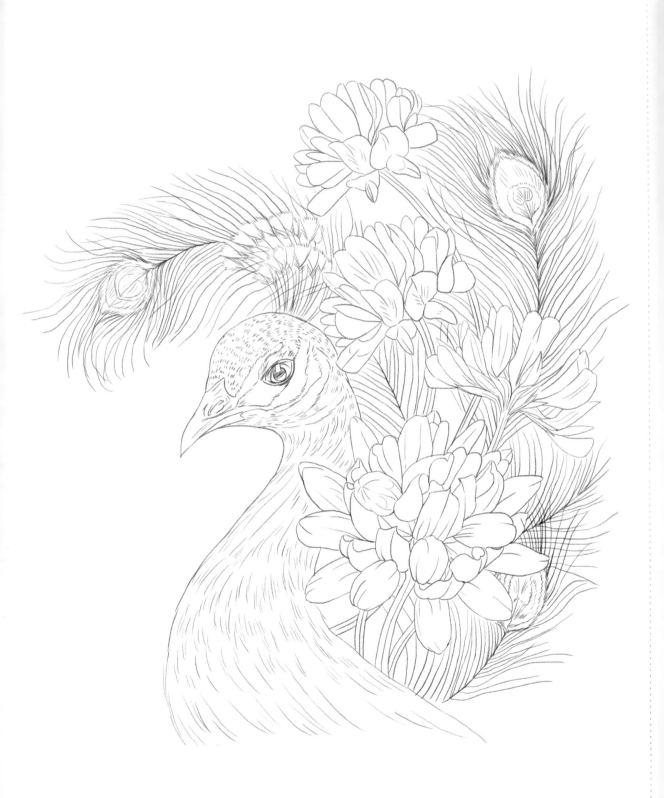

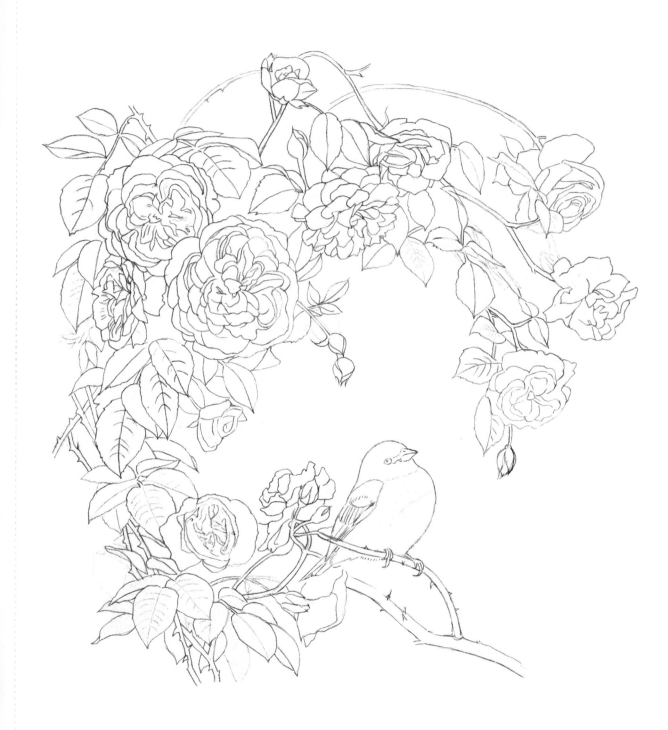

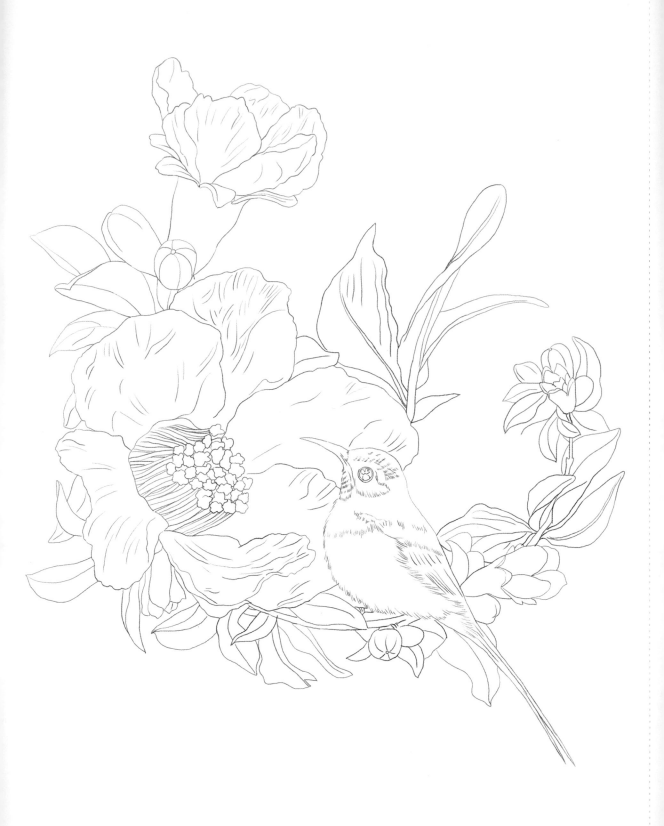

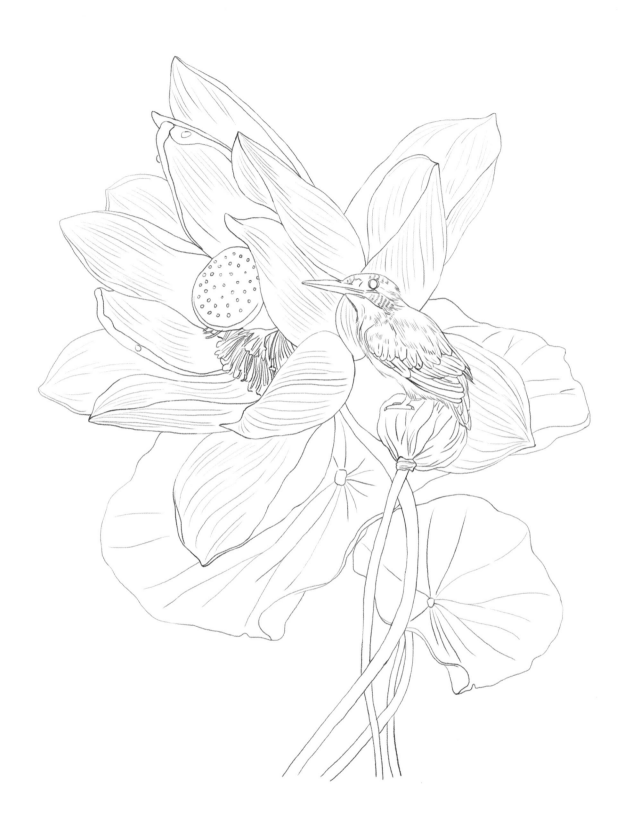

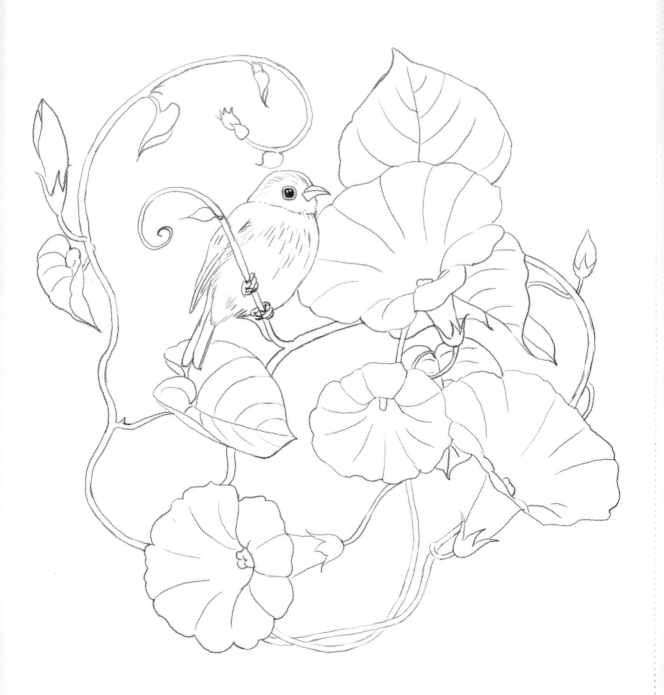

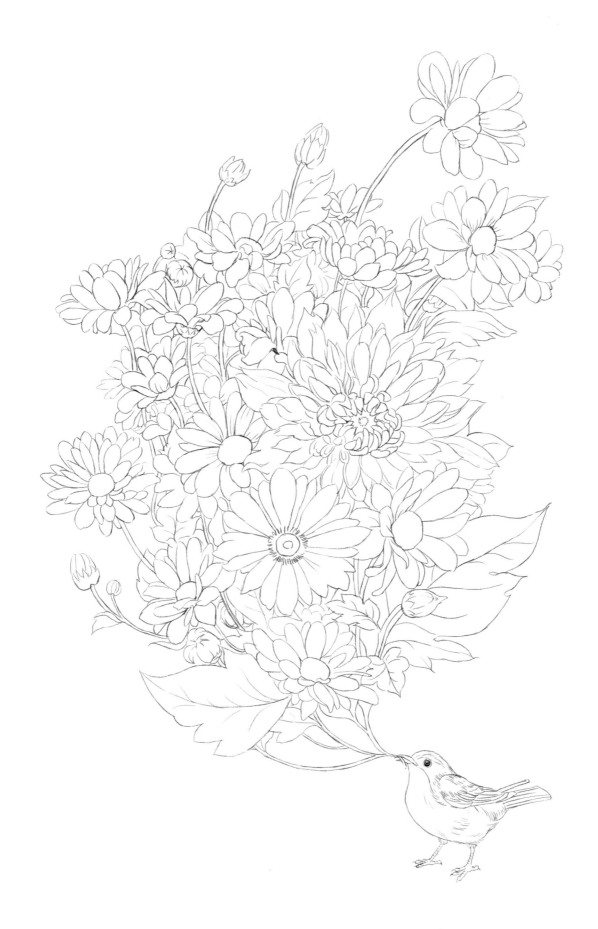

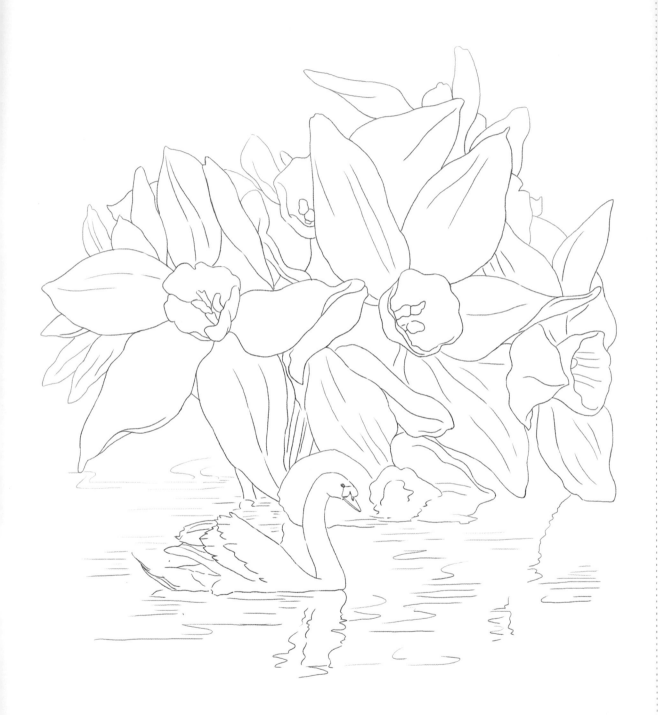

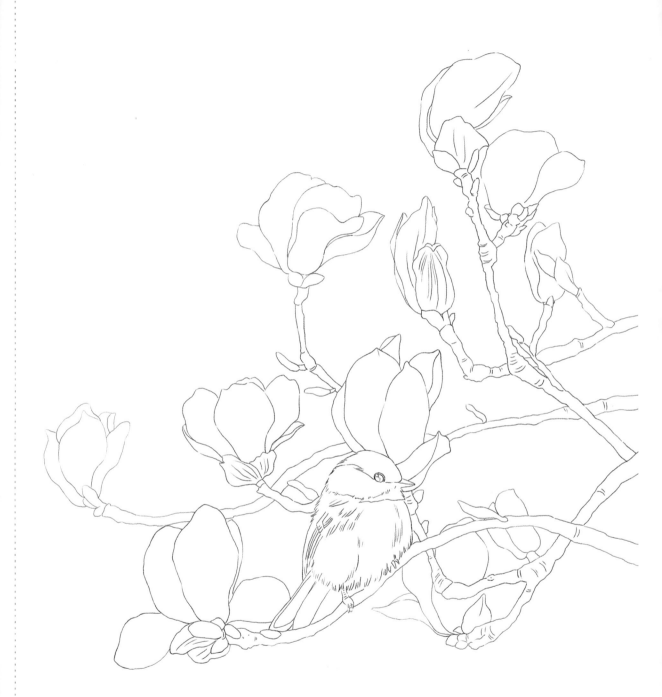

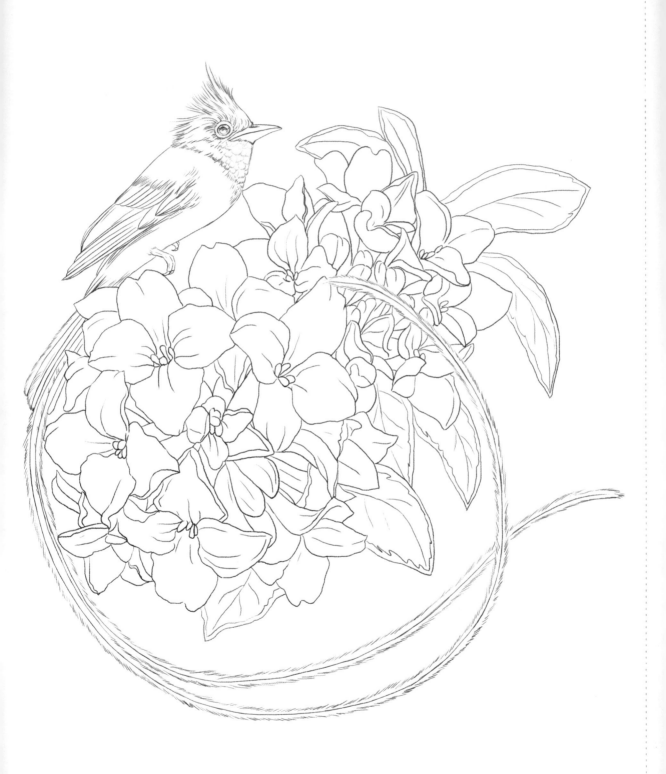